>SMALL GRAPHICS

ROCKPORT

GLOUCESTER MASSACHUSETTS

>SMALL GRAPHICS

DESIGN INNOVATION FOR LIMITED SPACES

Cheryl Dangel Cullen

R O C K P O R T

P U B L I S H E R S

First published in the United States of America by
Rockport Publishers, Inc.
33 Commercial Street
Gloucester, Massachusetts 01930-5089
Telephone: (978) 282-9590
Facsimile: (978) 283-2742

ISBN 1-56496-693-3 332640. 741.6c4L

10 9 8 7 6 5 4 3 2 1

Design: Chen Design Associates, San Francisco
Photography, cover and pages 1-11: Justin Thomas Coyne

Printed in China.

Contents

NOBODY SEES A FLOWER, REALLY—
IT IS SO SMALL—WE HAVEN'T TIME,
AND TO SEE TAKES TIME,
LIKE TO HAVE A FRIEND TAKES TIME.
—Georgia O'Keeffe

Whoever said "Size doesn't matter" never tried to fit a logo, company name, contact name, title, address, phone, fax, cellular number, and e-mail and Web site address onto the front of a 3 1/2" x 2" (9 cm x 5 cm) business card. The fact is, size does matter—especially when you're faced with designing a sizeable message and yet, you're short on space.

Small designs don't have space to spare. There's no room to waste—no extra space for frivolous graphics or extraneous copy. When designing for limited spaces—sometimes as small as 3/8" (1 cm) square—every design element, every word is a deliberate choice. And, as one might guess, each choice can pose a quandary: Will a serif typeface crowd my design? Will four-color process expand or constrict the layout? How much copy is too much? Is this type getting too small to be legible? I have too much copy, but what can I cut? Designers the world-over who have wrestled with the same issues and found their own solutions to gain maximum impact in a limited amount of space provide insight to these questions in *Small Graphics*:

Design Innovation for Limited Spaces. Included are small graphics that are interactive, expansive, and elaborate, while others are minimal in their design. Several use photos to communicate, while others use illustrations. Some examples are beyond description. In each case, the designer has learned how to maximize the impact of the message in keeping with its size—no matter how small.

Small designs are not insignificant because of their size. Designs, though small in scale, communicate in a big way and have no less impact on their audience than the tallest marquee—consider the impact of the transistor, the Pentium chip, the miniskirt, and the bikini on our culture.

Small Graphics: Design Innovation for Limited Spaces is a reference guide and idea starter for designing when space is at a premium, providing hundreds of ideas for making effective use of even the smallest spaces. Here, you'll find more than 125 small projects, including logos, business cards, premiums, identity systems, direct-response marketing, point-of-purchase material, stamps, and packaging. There's even a Web site billed as the "world's smallest," along with all sorts of promotional materials from more than ninety design studios around the world.

These projects are sure to inspire creative ideas so you'll never have to wonder what could have been possible if only you had more space.

So turn the page and, in the words of comedian Steve Martin, "Let's get small."

IT'S A SMALL WORLD,
BUT I WOULDN'T WANT
TO PAINT IT.
—Stephen Wright

Engaging graphics are interactive graphics. To be effective, they need our help and participation. Without it, they remain unopened, unread, and unexplored. The good ones seize upon our curiosity and entice us to open them, pull a tab, or peek behind a die-cut. Small, interactive graphics attract us through their nuances and, though they are usually subtle, they are no less powerful than large graphics that

engage us through their sheer magnitude. Small graphics speak softly—almost in a whisper. They engage our senses and get us involved. We engage machinery by turning it on; we engage the senses by igniting the imagination.

The graphics in this collection pique our interest and encourage our playfulness. They act on us and we actively respond. They invite us to poke and prod to see what they are all about. Engaging graphics can occupy our attention any number of ways. They may ask us to play a game or ask us to wear them; others are tactile and invite our touch. Regardless of their approach, these designs require a certain amount of effort, a degree of participation on our part that in itself makes them all the more memorable. Just as one is more likely to recall a person once they've met, an individual is more likely to remember a mailing, an advertisement, or a business card that tweaks their imagination and takes them out of the moment—even if it is for just a brief while.

These graphics don't go at it alone. Any number can play.

design firm: BASE ART COMPANY
art director/designer:
TERRY ALAN ROHRBACH
copywriter: KAREN ROHRBACH
printer: IN HOUSE
paper stock: ARCHES WATERCOLOR
PAPER, BLUEPRINT
printing: 4-COLOR PROCESS
quantity: 50
dimensions: 4 3/4" x 7"
(12 CM x 18 CM)

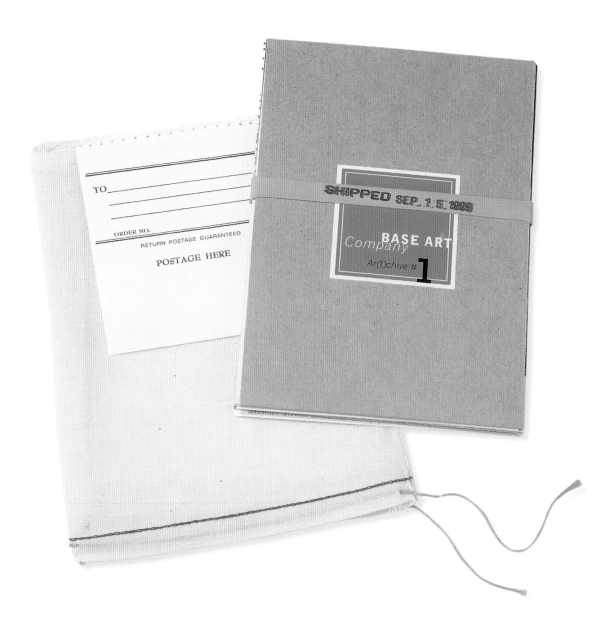

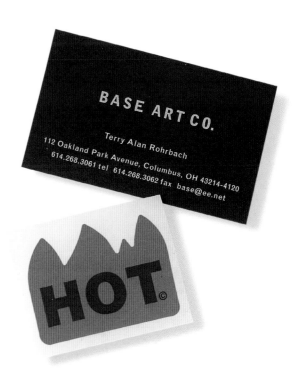

project: **BASE ART COMPANY SELF-PROMOTION**
client: **BASE ART COMPANY**

Base Art Company packs a lot of information into this small mailer that arrives in a cloth bag and begs to be opened. Inside, heavy cardboard flanks the contents, which are held together with a rubber band stamped with the mailing date. The piece showcases the shop's work, and it has won appointments with several new clients. "By incorporating unexpected materials into the design—the blueprint, cloth bag, etc.—we created a piece that is built on a handmade quality," says Terry Alan Rohrbach.

design firm: **Sagmeister Inc.**
art director/designer: **Stefan Sagmeister**
printer: **Image Tech**
paper stock: **Strathmore Writing**
printing: **1 color**
quantity: **3,000**
dimensions: **3 5/8" x 2"**
(9.5 cm x 5 cm)

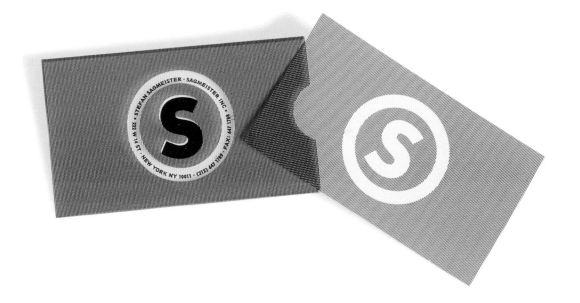

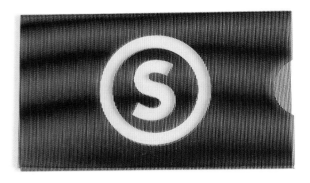

project: **Sagmeister Inc. Business Card**
client: **Sagmeister Inc.**

The distinctive *S* of the Sagmeister Inc. logo takes on dimension in this interactive business card that entices the recipient to slide the card out of its vinyl sleeve to reveal the address, telephone, and fax numbers. "We produce designs that involve the viewer, so it is only fitting that our business card do the same thing," says Stefan Sagmeister.

design firm: OH BOY, A DESIGN COMPANY
designer/illustrator: MIMI O CHUN
copywriter: DAVID SALANITRO
printer: GRAPHIC CENTER
paper stock: BRILLIANT ART GLOSS C2S 12 PT.
printing: 7 COLORS, SHEETFED
quantity: 4,750 SETS
dimensions: 3" x 4 1/2"
(8 CM x 11 CM)

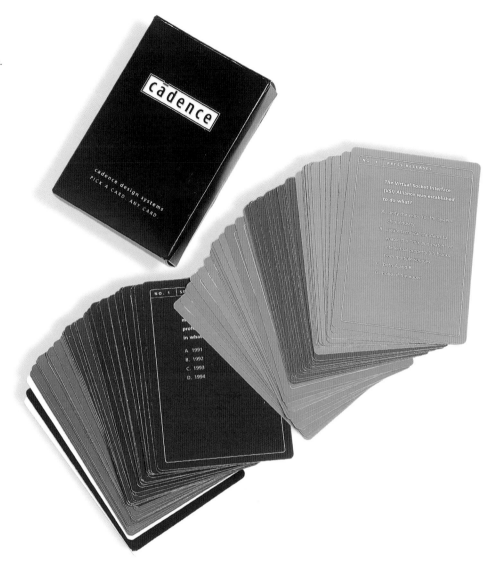

project: **CADENCE PRESS BOX**
client: **CADENCE DESIGN SYSTEMS**

Oh Boy, A Design Company created this card game to provide editors and reporters with adequate information on Cadence Design Systems. It helps them outline articles without the tedium of wading through a monster-sized press kit. The object of the game is to be the first to build a customized unicycle using bicycle parts illustrated on the back of each color-coded card by correctly answering questions about Cadence's products. Of course, not all questions are entirely serious. As a result, the game's playfulness engages its audience, not an easy feat with editorial types accustomed to being wooed for media coverage.

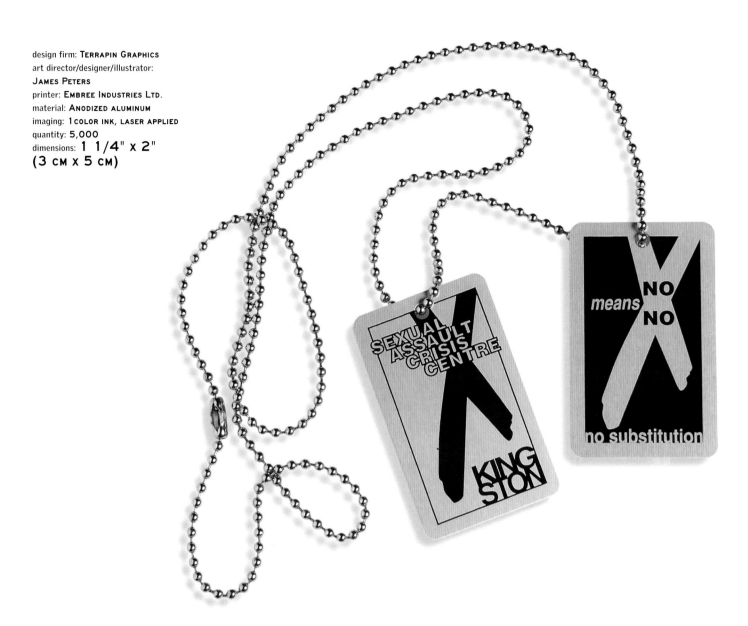

design firm: **Terrapin Graphics**
art director/designer/illustrator:
James Peters
printer: **Embree Industries Ltd.**
material: **Anodized aluminum**
imaging: **1 color ink, laser applied**
quantity: **5,000**
dimensions: **1 1/4" x 2"
(3 cm x 5 cm)**

project: **"No Means No" Dog Tags**
client: **Sexual Assault Crisis Centre**

Following a court ruling in a sexual-assault case that became known as the "No means no" law, the Sexual Assault Crisis Centre wanted something that would empower women to resist unwanted sexual advances. Using an X, a symbol commonly associated with the word "no," James Peters designed these dog tags. His priority was to keep the message simple to avoid crowding the small space, "A trick I like to think of as a thimbleful of ocean," Peters says.

design firm: TERRAPIN GRAPHICS
art director/designer: JAMES PETERS
printer: CLARKE LITHOGRAPHING LTD.
imaging: 2 COLORS
quantity: 10,000
dimensions: 2" x 3 1/2"
(5 CM X 9 CM)

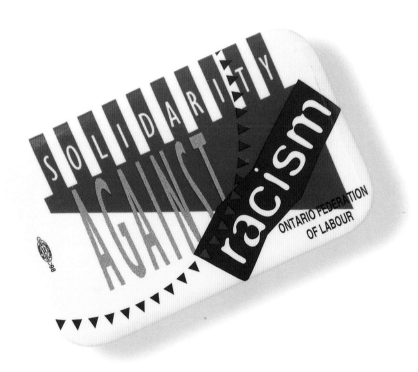

project: ONTARIO FEDERATION OF LABOUR ANTI-RACISM BUTTON
client: ONTARIO FEDERATION OF LABOUR, HUMAN RIGHTS DEPARTMENT

James Peters had to match the colors and design elements of eight different brochures when he took on the task of creating this button. The challenge was to meet these demands and yet design a button that would be attractive enough to get worn. He took some liberties with the legibility of the slogan, but compensated for it by emphasizing the word "racism," which was the main point. Size wasn't as much of an issue with this project as color. Peters would have preferred colors with more punch, but at the same time, he had to match the color palette used in other client materials.

design firm: 5D STUDIO
art director: JANE KOBAYASHI
designer: GEOFF LEDET
illustrator: IDEO
photographer: ELYN MARTON
copywriter: BOB BECK
printer: TYPECRAFT
paper stock: COVER—BLACK QUEST 88 LB.
COVER; TEXT—TOPKOTE GLOSS 78 LB. COVER
printing: 1 OVER 1, SHEETFED
quantity: 10,000 (10,000 REPRINT)
dimensions: 2 3/4" x 4 1/4"
(7 CM X 10.5 CM)

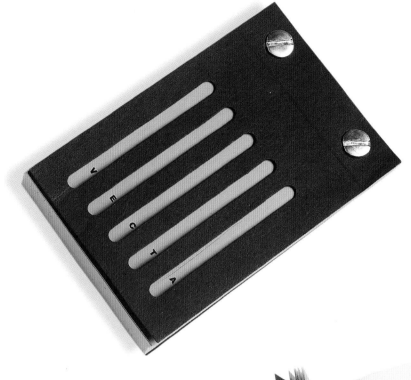

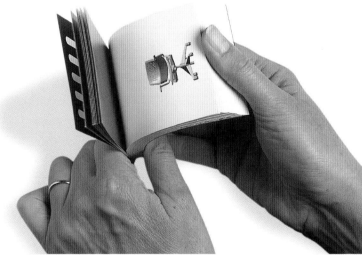

project: VECTA FLIP-BOOK
client: VECTA

Prospective buyers of the Vecta chair—the first chair of its kind that can be nested for easy storage—can enjoy their own personal sales presentation and demonstration in the palm of their hand with this flip-book. Flip the pages and watch the chairs roll out, nest, adjust into a variety of positions, and swivel about in the same manner that was used for cartoons before computer-generated animation became the norm. Vecta used the book as a promotional giveaway to introduce the chair and evoke consumer curiosity.

design firm: **Zingerman's**
art director/designer: **Lakshimi Shetty**
illustrator: **Ian Nagy**
copywriters: **Ari Weinzweig, Lynn Fiorentino**
printer: **Kolossos Printing**
paper stock: **White label stock**
printing: **5 colors, digital**
quantity: **500**
dimensions: **2 3/4" x 7 1/2" (7 cm x 19 cm)**

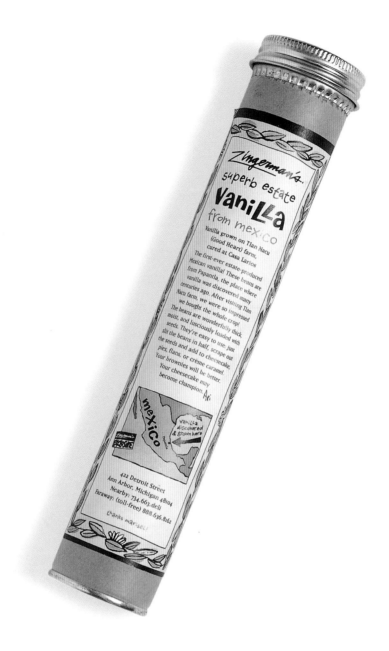

project: **Zingerman's Superb Estate Vanilla from Mexico Packaging**
client: **Zingerman's**

Zingerman's, a popular deli/bakery/ gourmet shop in the college town of Ann Arbor, Michigan, is known for its tasty foods and the colorful, hand-rendered look of its packaging. This packaging is no exception. It relies on a map of Mexico and abundant copy to tell why Mexican estate-grown vanilla beans are superior to Madagascar vanilla. The design invites browsers to pick up the package, read, and, hopefully, buy.

design firm: **AdamsMorioka**
designers: **Sean Adams, Noreen Morioka**
printer: **Coast Litho**
paper stock: **Mohawk Superfine Bright White 80 lb. cover**
printing: **3 colors, offset**
quantity: **1,000**
dimensions: **BOX—**
6 3/4" x 4" x 2 1/2"
(17 cm x 10 cm x 6 cm)
cards—5 3/4" x 3 3/4"
(15 cm x 10 cm)

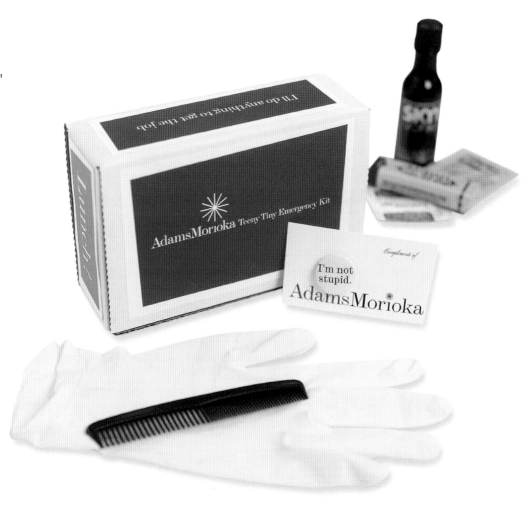

project: AdamsMorioka Teeny Tiny Emergency Kit
client: **AdamsMorioka**

So that you'll always be prepared for unexpected client meetings, AdamsMorioka developed this emergency kit. Bright labels adorn the box and propose scenarios—deadlines, lunch?—that are sure to prompt even the calmest individual to cry out for help. Fortunately, AdamsMorioka comes to the rescue with everything from a miniature bottle of vodka and gum to a pair of rubber gloves, aspirin, and a condom. The package also includes a few tips for a successful impromptu meeting, as well as a reminder to send a thank-you note.

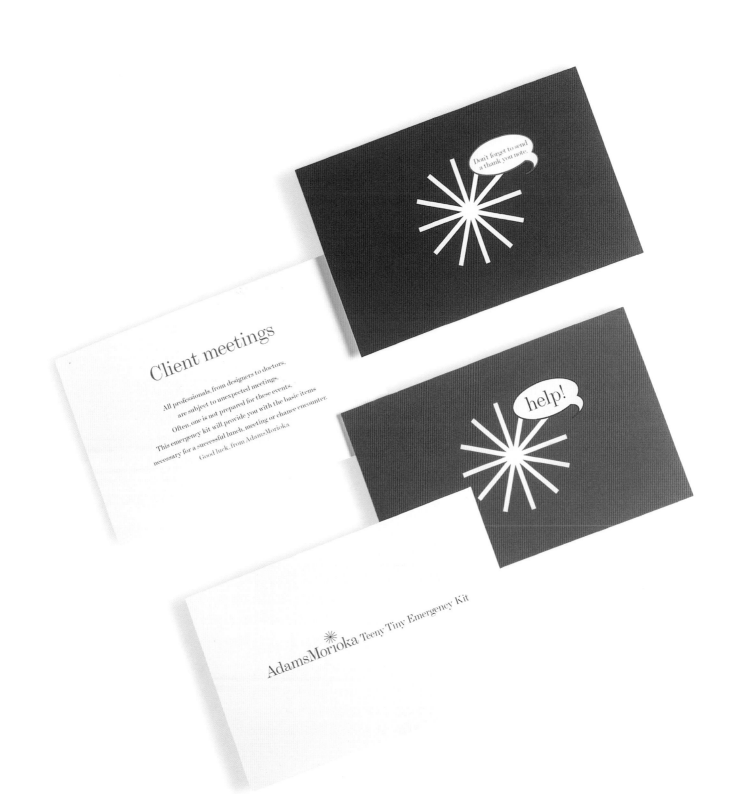

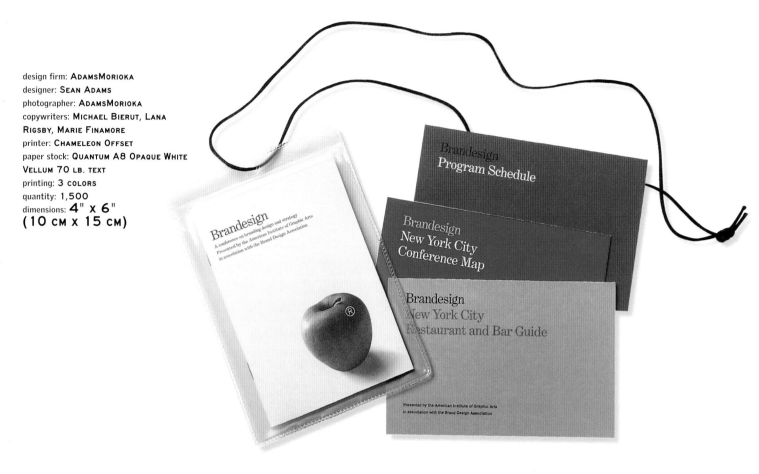

design firm: AdamsMorioka
designer: Sean Adams
photographer: AdamsMorioka
copywriters: Michael Bierut, Lana
Rigsby, Marie Finamore
printer: Chameleon Offset
paper stock: Quantum A8 Opaque White
Vellum 70 lb. text
printing: 3 colors
quantity: 1,500
dimensions: 4" x 6"
(10 cm x 15 cm)

project: **BRANDESIGN CONFERENCE PROGRAM MATERIALS**
client: **AMERICAN INSTITUTE OF GRAPHIC ARTS**

AdamsMorioka manages to pack a complete overview of the Brandesign Conference—including speaker biographies, a program schedule, and a map of New York City with a guide to its restaurants and bars—in a single pocket-sized booklet that slides into a vinyl packet. While the packet contains everything one would want to know about this design conference, it isn't bulky or heavy but can be worn around the neck, much like members of the media wear their credentials. Everything is kept together within easy access and nothing is about to get lost.

(OPPOSITE)
design firm: Studio GT & P
art director: Gianluigi Tobanelli
printer: Tavernelli Int.
printing: 4 colors, offset
quantity: 300,000
dimensions: 3/4" x 3/4" x 2 1/2"
(3 cm x 3 cm x 5 cm)

project: **BORGOVIVO EXTRA VIRGIN OLIVE OIL
AND ITALIAN DRESSING PACKAGING**
client: **DIVA INTERNATIONAL S.r.L**

These little bottles of olive oil and Italian dressing look almost too good to use. They are inviting and indicative of high quality. Moreover, the labeling on these gourmet products is upscale, a quality rarely found in airline in-flight cuisine—the venue in which these bottles, containing thirteen milliliters of product, are used.

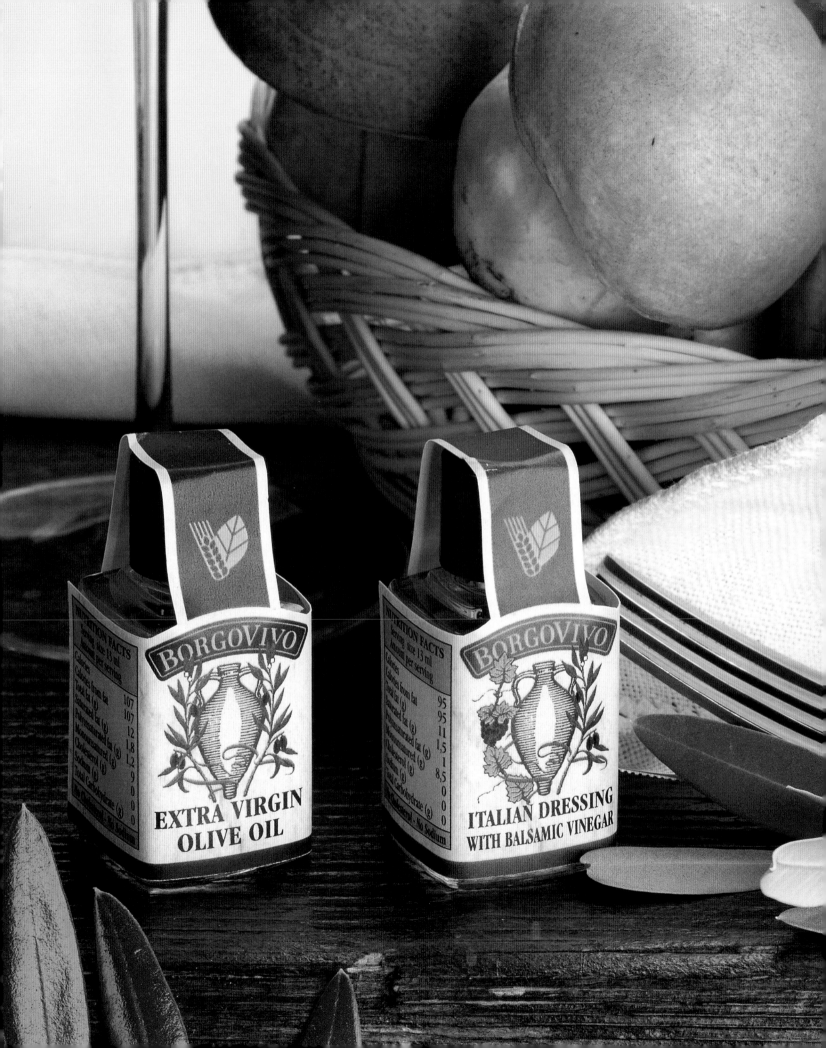

design firm: KENZO IZUTANI OFFICE
CORPORATION
art director: KENZO IZUTANI
designers: KENZO IZUTANI, AKI HIRAI
printers: KYURYUDO PRINTING, NISSYO
PRINTING
paper stock: NEW AGE 4/6 135 KG
printing: 4 COLORS, OFFSET
quantity: 1,000 EACH
dimensions: 3" x 5"
(8 CM X 13 CM)

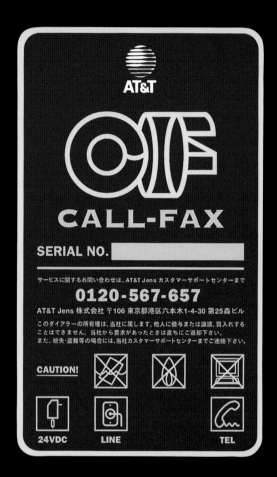

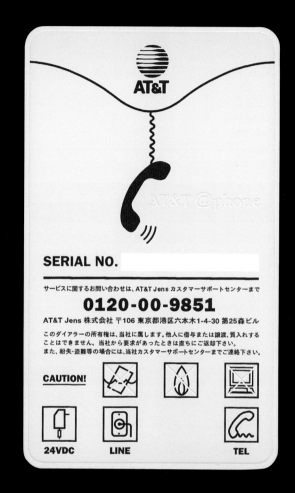

project: AT&T PHONE AND FAX DIALER LABELS
client: JENS CORPORATION

The simple graphics on these labels
provide a vivid reminder of AT&T
while the label itself is a handy
keeper that ensures AT&T's service
numbers will be easily found when
they are needed.

design firm: KENZO IZUTANI OFFICE
CORPORATION
art director/computer graphics: KENZO IZUTANI
designer: AKI HIRAI
printer: NIIMURA PRINTING
paper stock: VENT NOUVEAU 135 KG.
printing: 5 COLORS, OFFSET
quantity: 400
dimensions: 2 1/4" x 3 1/2"
(5.5 CM X 9 CM)

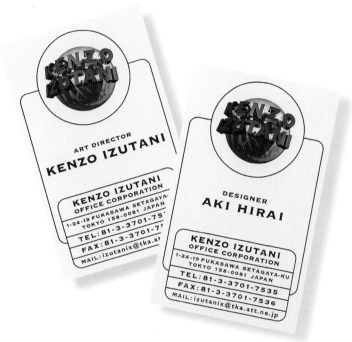

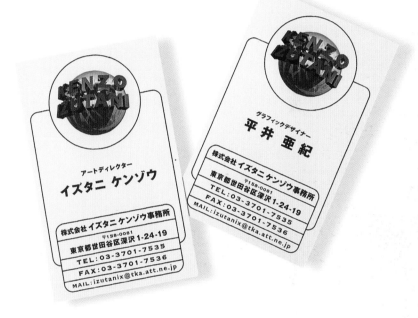

project: KENZO IZUTANI OFFICE CORPORATION BUSINESS CARDS
client: KENZO IZUTANI OFFICE CORPORATION

For many bilingual companies, their corporate brochures and business cards must be printed in their native as well as a second language so that they can anticipate any client's needs. Kenzo Izutani's business card works in two languages: One side has a pale green background and is printed in Japanese, while the reverse, printed with a blue background, conveys the same information in English.

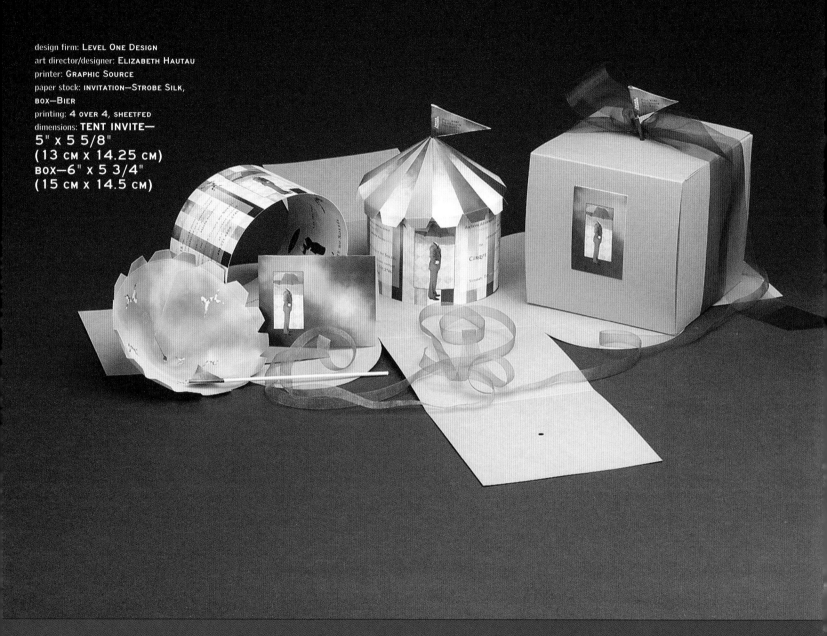

design firm: LEVEL ONE DESIGN
art director/designer: ELIZABETH HAUTAU
printer: GRAPHIC SOURCE
paper stock: INVITATION—STROBE SILK,
BOX—BIER
printing: 4 OVER 4, SHEETFED
dimensions: **TENT INVITE—**
5" x 5 5/8"
(13 CM x 14.25 CM)
BOX—6" x 5 3/4"
(15 CM x 14.5 CM)

project: ARTHUR ANDERSEN CIRQUE DU SOLEIL INVITATION
client: ARTHUR ANDERSEN

Level One Design created this invitation to a Cirque du Soleil performance to resemble a miniature circus with plenty of gadgets for interactive play. The invitation was designed with presentation and showmanship as a priority. First, the boxes were hand-delivered to recipients. Atop the box, a flag reads, "Pull here to unleash the magic." After removing the ribbon and pulling the flag, the invitation unfolds to reveal a circus tent, the outside of which is printed with the particulars of the event. Titles to the songs in the performance and tiny acrobats floating in space decorate the tent's interior. Amid all of this is a response card. Finally, the flag can be placed back into the tent so that the piece can be kept as a souvenir.

design firm: **Studio Karavil**
art director/designer: **Bessi Karavil**
printer: **Nuovo Polistylegraf**
quantity: **2,000 each**
dimensions: **Hang Tag—**
2 1/4" x 2 1/4"
(5.25 cm x 5.25 cm)
Labels—various

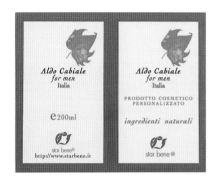

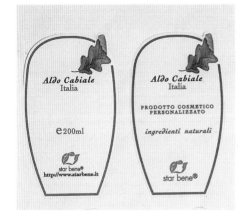

project: **Star Bene Natural Cosmetics Packaging**
client: **Star Bene**

Star Bene specializes in natural cosmetic products and sells them primarily through e-commerce using the corporate Web site, located at www.starbene.it. While this necessitates featuring the Web address prominently on all packaging components, the address is not so overbearing that it detracts from the simple elegance of the design— distinguished by an oak leaf and a red-brown color palette for the men's products, and a green color scheme for the women's line.

design firm: NEWMAN FOLEY LTD.
creative director: JIM FOLEY
designers: GLENN HADSALL, DAVID
MCMAHON, AMY KEIDERMAN
illustrator: GLENN HADSALL
photographer: PETE LACKER
copywriter: DAVID MARTIN
programmers: DAVID MCMAHON, MARK FINKS
printer: PADGETT PRINTING
printing: 5 OVER 5
dimensions: 5 1/4" x 7 1/2"
(13.5 CM X 19 CM) FOLDED

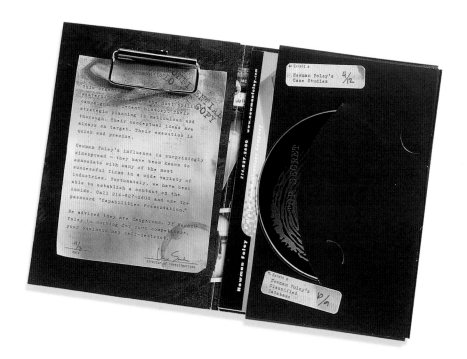

project: NEWMAN FOLEY LTD. SELF-PROMOTION BROCHURE AND CD-ROM
client: NEWMAN FOLEY LTD.

Don't underestimate the power of this self-promotion because of its diminutive size. It grows when opened to reveal a considerable amount of information on Newman Foley, including the firm's personality—a fun, humorous group—and its capabilities from corporate identity to CD-ROM production. Ordinarily, the jacket and the CD-ROM might be enough of a demonstration to sell a client on a firm's creative approach, but as an added bonus, the packet includes six picture postcards, providing even more insight into the designers' thinking.

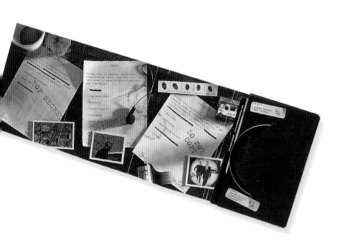

design firm: GREENFIELD/BELSER LTD.
art director: BURKEY BELSER

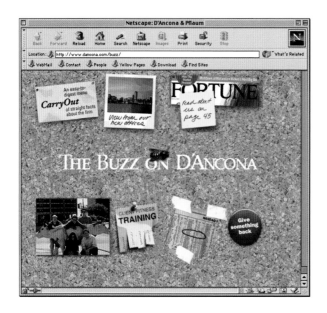

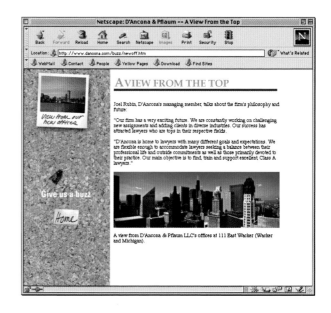

project: **D'ANCONA & PFLAUM RECRUITING WEB SITE**
WWW.DANCONA.COM
client: **D'ANCONA & PFLAUM**

Greenfield/Belser Ltd. created this Web site for D'Ancona & Pflaum to attract prospective lawyers and recruits, while demonstrating the firm's technical and legal skills. The design doesn't overpower, but makes its point with a casual approach—utilizing a variety of small objects pinned to a bulletin board to replicate the look of a catch-all announcement board one might find in a college dormitory. Because the information is presented in small amounts, it is memorable. Visitors travel from page to page picking up scraps of information they are likely to remember after they move on.

design firm: VIA, INC.
art director: OSCAR FERNÁNDEZ
designers: ANDREAS KRANZ, M.
CHRISTOPHER JONES, JENNIFER JUAN
copywriter: WENDIE WULFF
production: SHELLY POMPONIO
printer: BYRUM LITHOGRAPHY
paper stock: STARWHITE VICKSBURG
80 LB. COVER AND 100 LB. TEXT
printing: 2 COLORS, OFFSET AND PERFECT BOUND
quantity: 5,000
dimensions: 3 1/4" x 3 1/4"
(8.5 CM X 8.5 CM)

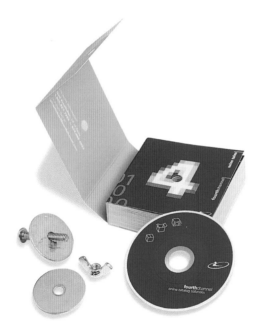

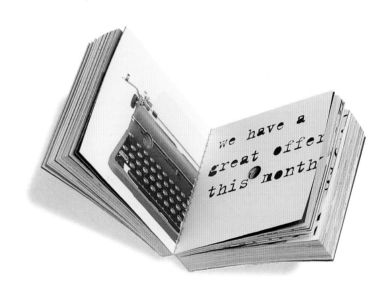

project: FOURTHCHANNEL "SALES TALES" TRADE SHOW GIVEAWAY
client: FOURTHCHANNEL

Who wouldn't be intrigued by this little storybook cube that is held together with a wing nut and bolt? Apparently, not many, according to designers at VIA, Inc., who created this book of "sales tales" to introduce the fourthchannel—a company dedicated to e-commerce—to prospects attending a trade show. When curiosity got the best of them, recipients disassembled the book and discovered what the four selling channels represent and what the fourthchannel has to offer. They also found fourthchannel's on-line catalog solutions on a miniature CD.

design firm: HEINS CREATIVE, INC.
art director/designer/illustrator: JOE HEINS
printing: 4 COLORS, SHEETFED
print quantity: 10,000
dimensions: 4 1/4" x 2 3/4"
(10.5 CM X 7 CM)

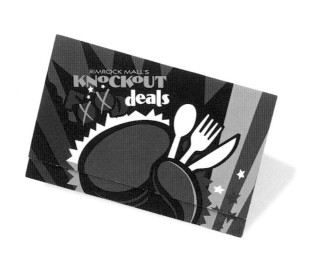

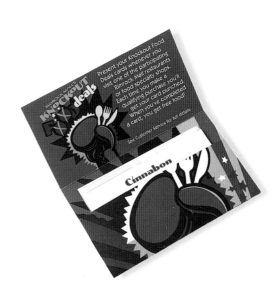

project: **RIMROCK MALL KNOCKOUT FOOD DEALS WALLET**
client: **RIMROCK MALL**

To promote Rimrock Mall food merchants, Heins Creative, Inc. created a "wallet" filled with twelve money-saving coupons that encourage repeat visits by giving the card holder a free item after a specified number of purchases. The coupons are business-card-sized—small, yet still large enough to communicate the details of each promotion—and fit perfectly into a folder wallet for safekeeping and easy retrieval. The bold color palette and convenient packaging assures this promotion won't be overlooked or get lost in the bottom of a desk drawer or purse.

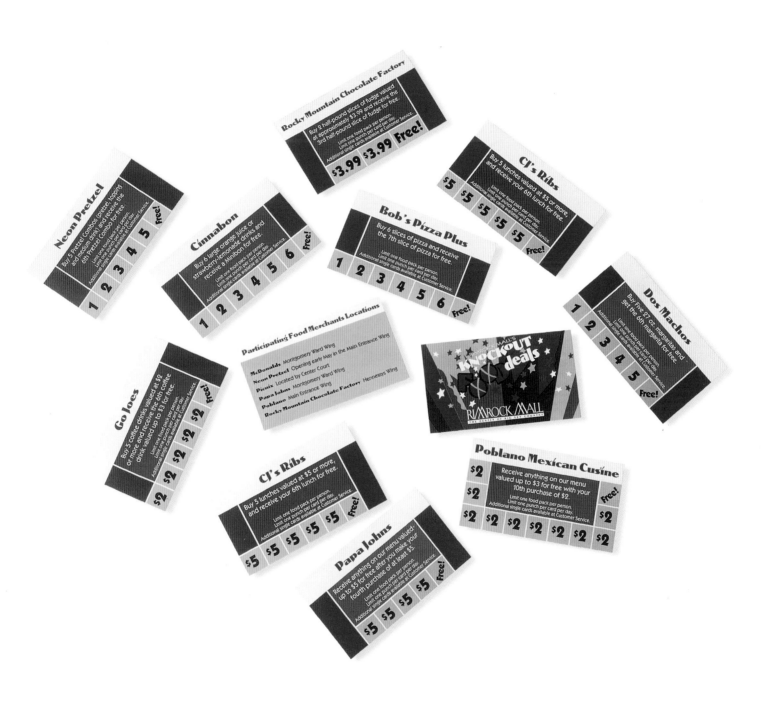

design firm: **C3 Incorporated**
art director: **Randall Hensley**
designers: **Randall Hensley,**
Scott Williams, Sylvia Chu
illustrator: **Scott Williams**
copywriters: **Randall Hensley,**
Billie Harber
programmers: **Chris Ranch, Martin**
Beauchamp
animator: **Richard Madigan**

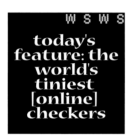
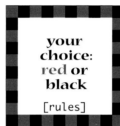
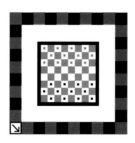
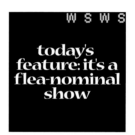
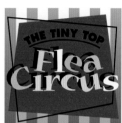

project: **World's Smallest Web Site www.smallestsite.com**
client: **C3 Incorporated**

"In a world obsessed with size, we wanted to see if we could create the world's smallest Web site," says Holmfridur Hardardottir, C3 Incorporated, of the firm's self-promotional site—known better by its initials, WSW (world's smallest web site). Designers and programmers worked with the minimum browser size (100 pixels x 100 pixels) to create a site about small things, including a miniature game of checkers and a flea circus. Because the public's attention is fleeting, features change daily. The WSW goes off-line at the end of each day and posts a test pattern until it comes back up the next day with an entirely new menu of tiny amusements.

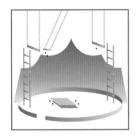

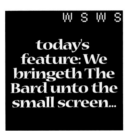
today's feature: We bringeth The Bard unto the small screen...
W S W S

The Plays of William Shakespeare

Henry VI, part 1
ct 1, Scene 1 West

in a world so obsessed with "bigness"

we think it's time to celebrate

things that just happen to be small.

design firm: SAYLES GRAPHIC DESIGN
art director/designer/illustrator:
JOHN SAYLES
printing: 4 COLORS, OFFSET
quantity: 5,000
dimensions: 1 1/2"
(4 CM) DIAMETER,
1/2" (1 CM) TALL

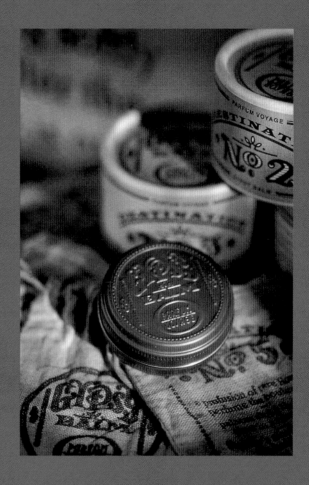

project: GIANNA ROSE GYPSY BALM PARFUM VOYAGE PACKAGING
client: GIANNA ROSE

Sayles Graphic Design's packaging design for Gypsy Balm Parfum Voyage suspends the product in beeswax and places it in a tiny copper tin, all of which plays to the "mystery and restless spirit of the gypsy lifestyle that inspired the fragrance," says John Sayles. To distinguish the copper tin, Sayles hand-rendered a curling typeface logo and had it embossed on the lid. Sayles also designed an inviting countertop display using two round shelves to hold samples and product. An additional steel round is screenprinted with the logo, and a tall crossbar on the display's backside holds a banner with scalloped edges and a lyrical poem.

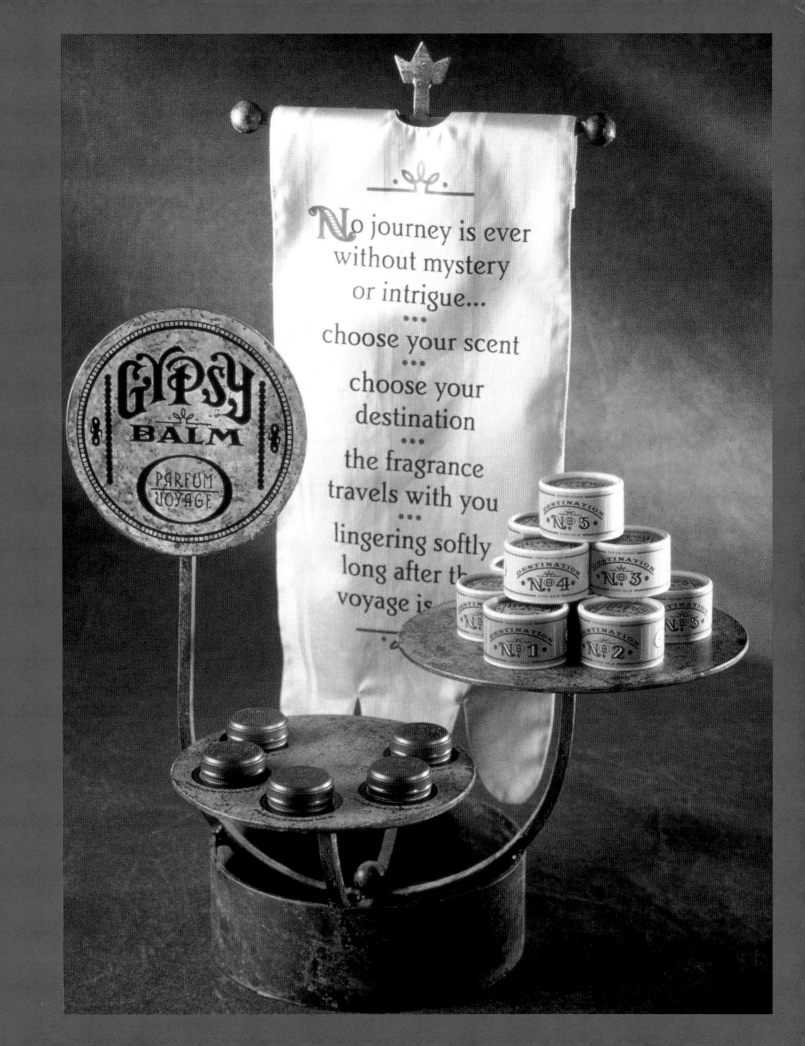

design firm: **ANA COUTO DESIGN**
creative director: **ANA COUTO**
designers: **ANA COUTO, NATASCHA BRASIL,**
CRISTIANA NOGUEIRA, DANILO CID
printer: **ARTES E OFICIOS**
materials: **ALUMINUM, 3M VINYL, ACRYLIC**
quantity: **PACK AND POSTCARD DISPLAY—70;**
2-POSTCARD DISPLAY—180
dimensions: **PACK AND POSTCARD**
DISPLAY—10 1/2" x 6"
(27 CM X 15 CM);
2-POSTCARD DISPLAY—12" x 6"
(30 CM X 15 CM)

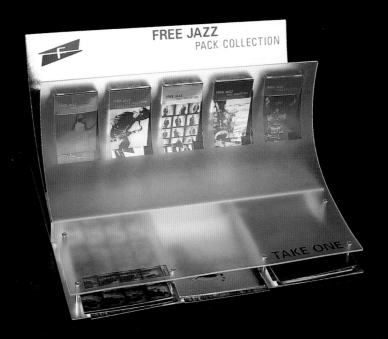

project: **FREE JAZZ FESTIVAL 1999 PACK**
AND POSTCARD DISPLAYS
clients: **SOUZA CRUZ AND STANDARD, OGILVY & MATHER**

"The concept of the Free Jazz Festival 1999 was based on the light that invades the city of Buenos Aires. The displays were developed to express this idea in eye-catching shapes and colors to match the young spirit of the festival," says Ana Couto. To graphically illustrate the feeling of light, designers constructed postcard displays using transparent acrylic, bright colors, and shiny silver. Because the countertop displays are compact, copy and graphics were kept to a minimum to emphasize, not detract from, the vibrant colors of the free "take one" postcards that promote the event.

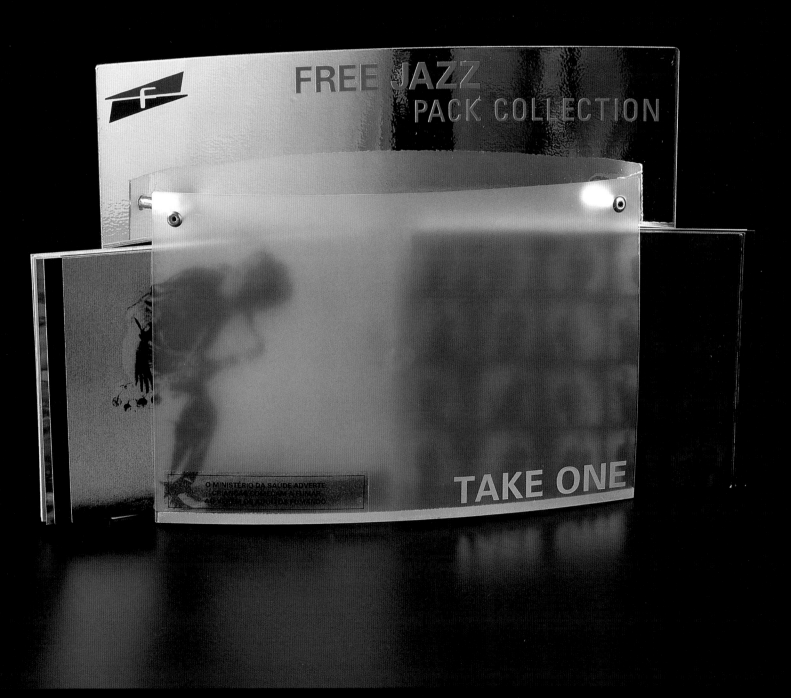

design firm: GRETEMAN GROUP
art director: SONIA GRETEMAN
designer/illustrator: JAMES STRANGE
copywriter: DIANNA HARMS
printer: PRINTMASTER
paper stock: PASSPORT
printing: 2 COLORS, OFFSET
dimensions: 1 1/2" x 2 1/8" x 1/2"
(4 CM x 5 CM x 1.25 CM)

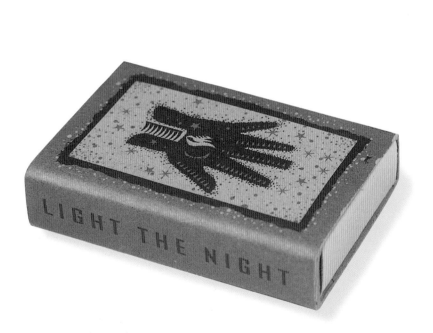

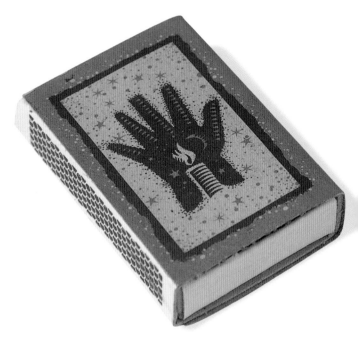

project: **LIGHT THE NIGHT MATCHBOOK**
client: **GRETEMAN GROUP**

In lieu of traditional holiday gifts, the Greteman Group made a charitable donation on behalf of its clients to an organization that provides energy assistance to senior citizens and the severely disabled. To communicate the importance of the gift, the Greteman Group established a theme, "Light the Night," and gave clients gifts of aromatic candles with a customized box of matches and a card. The theme is rendered graphically on the tiny matchbook that thanks clients for lending a hand to light the night.

design firm: GRAFIK COMMUNICATIONS
designers: JONATHAN AMEN,
GREGG GLAVIANO, JUDY KIRPICH
illustrators: JONATHAN AMEN, MICA STUDENTS
photographer: JOE RUBINO
copywriter: DEBRA RUBINO
printer: GRAPHTEC
printing: 6 OVER 6, SHEETFED
quantity: 50,000
dimensions: BROCHURE—5 1/2" x 7"
(14 CM x 18 CM);
CARDS—2 1/2" x 3 1/2"
(6 CM x 9 CM)

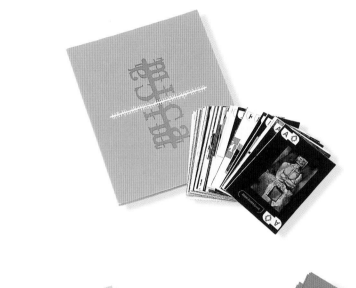

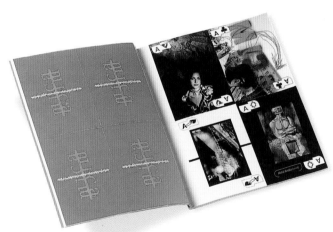 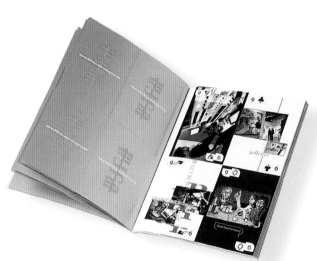

project: **MARYLAND INSTITUTE COLLEGE OF ART
DIRECT-MAIL PROMOTION**
client: **MARYLAND INSTITUTE COLLEGE OF ART (MICA)**

The Maryland Institute College of Art (MICA) asked Grafik Communications to create a direct-mail piece to attract prospective art students to the school. The resulting promotion not only met its goal, but became a keepsake as well. Designers used playing cards as the format, giving them fifty-two ways to show the diversity of MICA's students, their artwork, and more. They created the cards with very different graphic styles so they would be certain to appeal to all tastes. Of course, that was also part of the project's challenge. In addition to designing in such a small space, designers struggled to maintain design diversity among all fifty-two cards. To make the presentation cohesive and interactive, the cards were built into a booklet and perforated for disassembly.

design firm: **Grafik Communications**
designers: **Jonathan Amen,**
Gregg Glaviano, Judy Kirpich
printing: **1 color silk screen**
quantity: **500**
dimensions: **6 1/2" x 3/8"**
(17 cm x 1 cm)

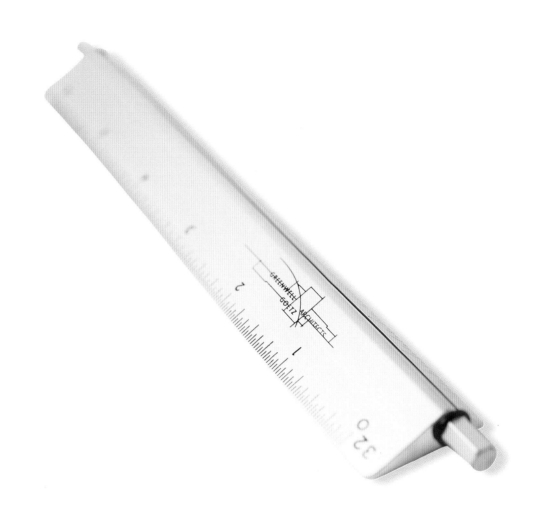

project: **Greenwell Goetz Architectural Scale**
client: **Greenwell Goetz**

Designing graphics small enough to be legible and attractive on premiums and giveaways can be a challenge, as Grafik Communications discovered when developing this high-quality architectural scale. The form and metal finish of the scale perfectly complement the elements of Greenwell Goetz's identity, also created by Grafik Communications. That was the easy part. More challenging was placing the logo and the design elements on the scale so that they maintained the integrity of the identity, yet worked within the limitations of silk-screening.

design firm: METALLI LINDBERG ADV.
creative director: LIONELLO BOREAN
account manager: STEFANO DAL TIN
material: PLASTIC
printing: 4 OVER 5

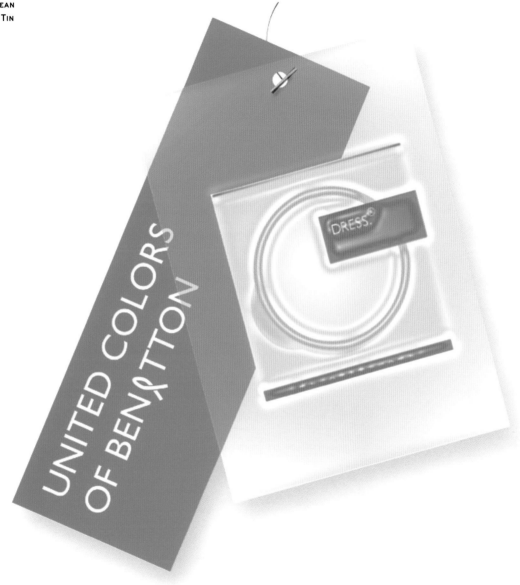

project: **BENETTON HANG TAG**
client: **BENETTON GROUP S.P.A.**

To commemorate World AIDS Day, Benetton sold T-shirts and other products with this special hang tag coupled with a condom. Designed by Metalli Lindberg Adv., the tag and condom packaging were printed in a variety of colors in keeping with Benetton's distinctive signature—"United Colors of Benetton." According to Lionello Borean, the design, "with its language, connects directly with an international target without tackling problems of social background." Consumers purchasing Benetton products received a clear reminder to practice safe sex.

design firm: STARBUCKS DESIGN GROUP
art director: MICHAEL CORY
designer/illustrator: MARTINA WITTE
project manager: DENA TAYLOR
production managers: ANN STEVENS,
PHILLIPA TEMMINK
printing: 3 COLORS, OFFSET
dimensions: 3" X 4 1/2"
(8 CM X 11 CM)

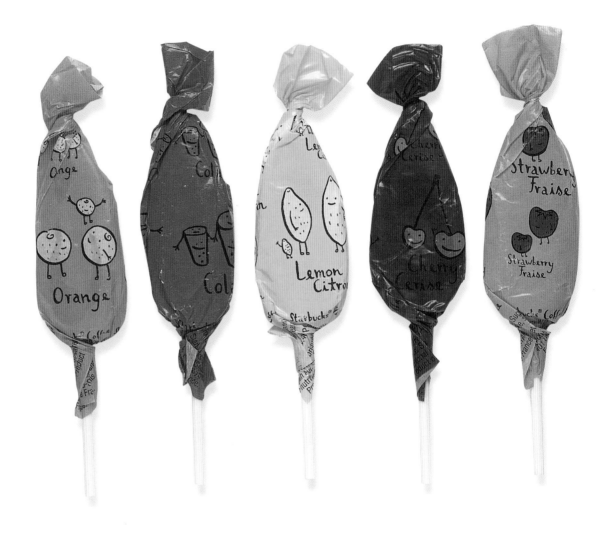

project: STARBUCKS LOLLIPOPS
client: STARBUCKS COFFEE COMPANY

Bright kid-appeal colors are the hall-mark of this collection of lollipops from Starbucks Coffee Company—which provides something for children while parents sip their coffee. Five lollipops are offered—cola, cherry, lemon/citrus, orange, and strawberry—and each is illustrated with fruity characters that define individual flavors. The design marks a departure from traditional Starbucks-inspired graphics in keeping with its target audience—children— also a departure for the gourmet coffee king.

design firm: **Starbucks Design Group**
art director: **Michael Cory**
designer: **Bonnie Dain**
paper stock: **Kraft, pressure-sensitive label**
printing: **1 color**
quantity: **10,000**
dimensions: **1 1/2" x 2" x 1"**
(4 cm x 5 cm x 2.5 cm)

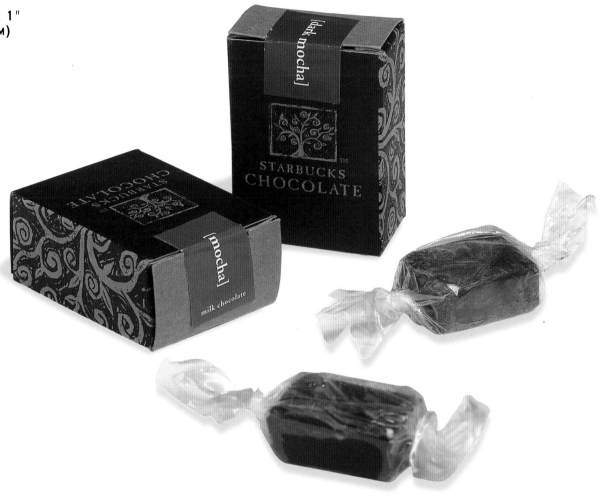

project: **Starbucks Chocolate Sampler Packaging**
client: **Starbucks Coffee Company**

"We wanted to create a box that would feel special—to make customers feel like they were receiving a gift and not a just a free handout," says Bonnie Dain, the designer who created the packaging for Starbucks Coffee Company's new chocolate tasting samples. The miniature box design is so rich in color and texture—despite its one-color printing and diminutive size—that consumers cannot mistake its value. Those lucky enough to pick up this free sample would not equate it with traditional "freebies" that are typically presented in a lower-end packaging to be cost-effective.

THE SMALLEST GOOD DEED IS BETTER THAN THE GRANDEST INTENTION.
—anonymous

Many things are illustrative. We recognize retirees for their illustrative service. Photographs can be illustrative. Traditions are often considered illustrative. By the same token, even narrative is illustrative. Illustrative works illuminate and clarify, and graphic illustrations—no matter how tiny—do likewise.

In fact, a small palette seems to be the perfect complement to illustrations, regardless of their individual style. Rather than being restrictive and bound with limitations, diminutive spaces provide an intimate canvas for graphic expression. This expression can include expansive, full-color illustrations that run border-to-border, as well as intricate line artistry that uses a quill pen.

Just as a handwritten note, love letter, or doodle convey an innate sense of intimacy, personality, and artistry—all on a small scale—so do these illustrations. They are comical, flamboyant, picturesque, contemporary, vintage, youthful, and sophisticated; and they all communicate on a personal level.

design firm: YFACTOR INC.
art director: ANYA COLUSSIO

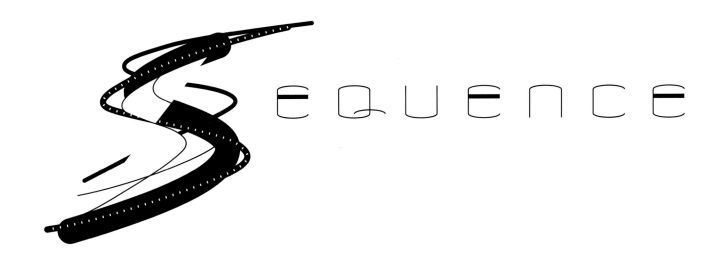

project: SEQUENCE PRODUCTIONS LOGO
client: SEQUENCE PRODUCTIONS

It is hard to miss the energy generated by this logo for Sequence Productions, a sound studio that needed a new identity to reflect its multidisciplinary approach to sound recording and composing. Yfactor Inc. developed this logo to complement the company's name, while also communicating a multilayered and textured symbolism to address the firm's diverse capabilities.

design firm: JIM MOON DESIGNS
art director/logo design: JIM MOON
illustrator: TOM HENNESSY
printer: SPECTRUM GRAPHICS
paper stock: B60 SIMPSON ESTATE EIGHT
WHITE COATED LABEL
printing: DOUBLE HITS OF PMS 185,
BLACK, AND AQUEOUS COATING
quantity: 28,000
dimensions: 2 1/8" x 1 7/8"
(6.5 CM X 4.75 CM)

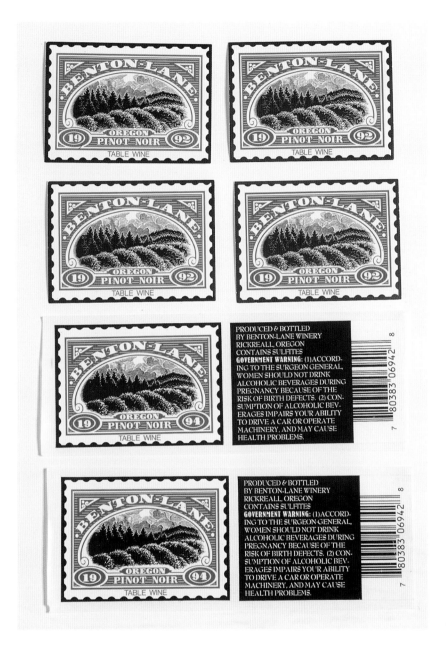

project: **BENTON-LANE WINE LABELS**
client: **BENTON-LANE WINERY**

The relatively small size, combined
with the two-color, illustrated, vintage-
stamp design, sets this wine label
apart from its competition on store
shelves. "The stamp lends a 'collectible'
look to the package that sets a positive
tone," says Jim Moon of the design.

design firm: GRECO DESIGN STUDIO
art director/designer/illustrator:
ANDREA GRECO
printer: PHONOPRESS SPA
paper stock: PATINATA 170 GSM
printing: 4 COLORS, OFFSET
quantity: 5,000
dimensions: 4 3/4" x 5 1/2"
(12 CM x 14 CM)

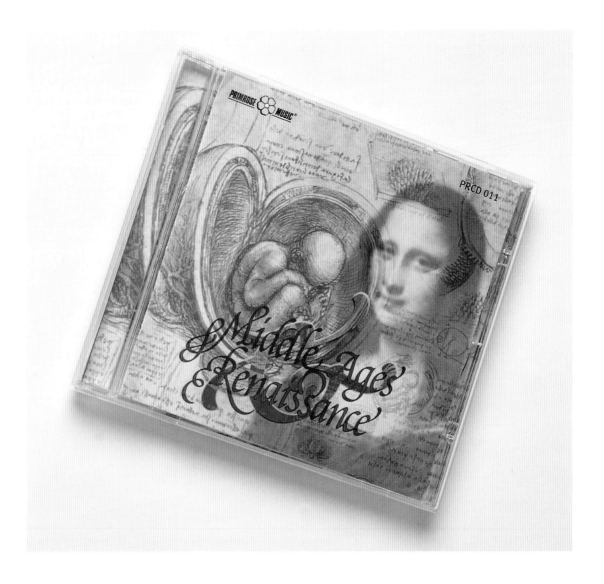

project: MIDDLE AGES & RENAISSANCE CD
client: PRIMROSE MUSIC LTD.

Andrea Greco artfully ties together
three independent graphics—an
illustration, a soft-focus rendering of
the *Mona Lisa*, and an interesting type
treatment—to make a cohesive,
visually provocative design in the
limited space of a CD jacket.

design firm: ZINGERMAN'S
art director/designer: LAKSHMI SHETTY
illustrator: IAN NAGY
copywriters: ARI WEINZWEIG, LYNN FIORENTINO
printer: GLENROY
paper stock: MATTE LABEL
printing: 2 COLORS, OFFSET
quantity: 5,000
dimensions: 2" (5 CM) DIAMETER

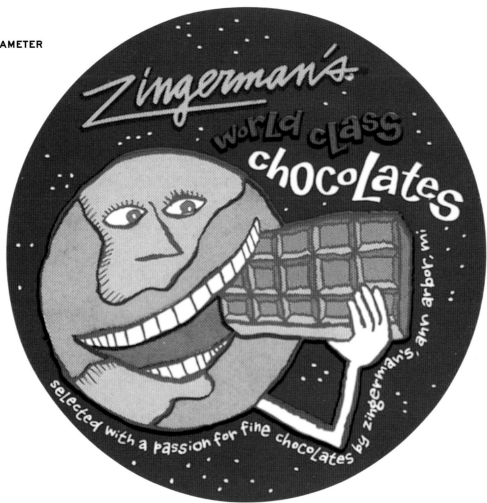

project: ZINGERMAN'S WORLD CLASS CHOCOLATES LABEL
client: ZINGERMAN'S

Carrying through on the slightly
offbeat illustrations for which
Zingerman's combination deli/
restaurant/bakery is recognized, this
label is used to let customers know
that the chocolates in question are
up to Zingerman's standards—a
weighty endorsement from this
gourmet enterprise—in the space
of 2 inches (5 cm).

design firm: **AdamsMorioka**
designer: **Sean Adams**
illustrator: **Daniel Jennewein**
printer: **Coast Litho**
paper stock: **Globrite**
printing: **2 colors, offset**
quantity: **1,000**
dimensions: **2" x 3 1/2"**
(5 cm x 9 cm)

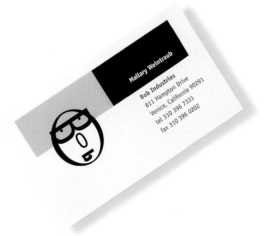

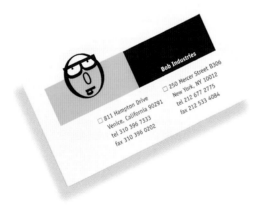

project: **Bob Industries Business Cards**
client: **Bob Industries**

AdamsMorioka puts its client's name— Bob Industries, a nondescript, yet curiously comic moniker—to full graphic use on business cards where "Bob" is given a facial identity and personality. This treatment allows recipients to identify employees with individual "Bob" faces, all of which makes this business card entertaining as well as informative. Look at the graphic closely and you'll see that all the facial elements even spell out "B-o-b."

design firm: **FACTOR DESIGN GMBH**
designer/illustrator/calligrapher:
MARIUS FAHRNER
paper stock: **BIBLE PAPER 40 G,**
COUNTRYSIDE 160 G
printing: **2 COLORS, OFFSET**
quantity: **2,500**
dimensions: **MAILING ENVELOPE—**
9" x 5 3/4"
(23 CM X 14.5 CM)
LABEL—3 1/8" x 1"
(8 CM X 2.5 CM)
HANG TAG—3 1/2" X 1
1/2" (9 CM X 4 CM)
GIFT WRAP (FOLDED)—5" X 7
1/2" (13 CM X 19 CM)

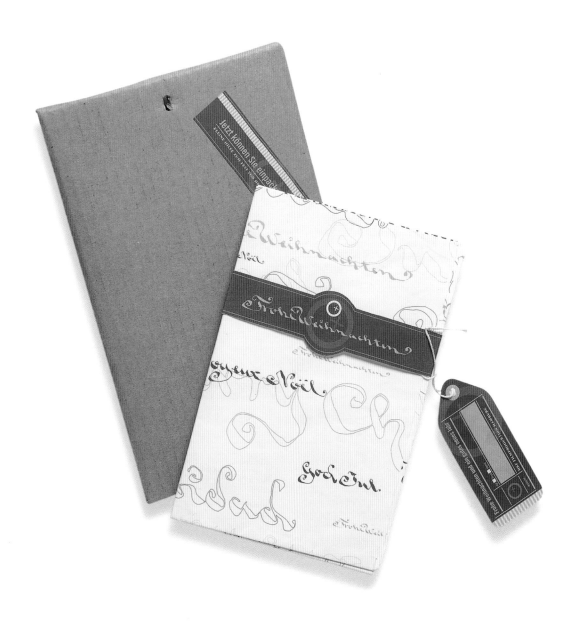

project: **HKF FILMPRODUKTION HOLIDAY MAILER**
client: **HKF FILMPRODUKTION**

HKF Filmproduktion's holiday card not only stands out from traditional greetings, but it has its practical application, too. When unfolded, it is a sheet of gift wrap with illustrated holiday messages penned in multiple languages from edge to edge. Regardless of whether the recipient celebrates a Joyeux Noël or a Buon Natale, they can wrap their gifts in style, courtesy of the sender.

design firm: HEINS CREATIVE, INC.
art director/designer/illustrator: JIM HEINS
paper stock: ROLL LABELS
printing: 4 COLOR PROCESS AND VARNISH
quantity: 500 EACH OF 7
dimensions: JELLY LABEL—
7 3/8" x 2 7/16"
(18.5 CM X 6 CM)
SYRUP LABEL—5 3/4" x 3"
(14.5 CM X 7.5 CM)

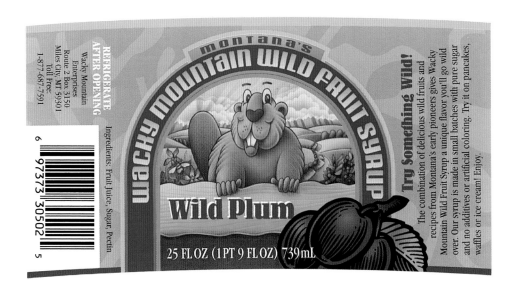

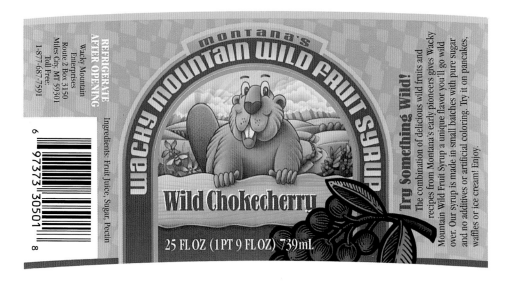

project: WACKY MOUNTAIN WILD FRUIT JELLY AND SYRUP LABELS
client: WACKY MOUNTAIN ENTERPRISES

Wacky Mountain Enterprises, a small manufacturer of jellies and syrups, wanted an identity that was progressive, fun, memorable—and colorful. Jim Heins delivered with these label designs that use, in his words, "wacky" background patterns and a beaver mascot. The color-coded labeling and whimsical illustrations set this packaging design apart from its competition on store shelves.

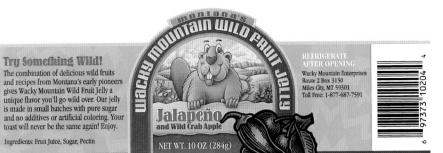

Try Something Wild!

The combination of delicious wild fruits and recipes from Montana's early pioneers gives Wacky Mountain Wild Fruit Jelly a unique flavor you'll go wild over. Our jelly is made in small batches with pure sugar and no additives or artificial coloring. Your toast will never be the same again! Enjoy.

Ingredients: Fruit Juice, Sugar, Pectin

REFRIGERATE AFTER OPENING
Wacky Mountain Enterprises
Route 2 Box 3150
Miles City, MT 59301
Toll Free: 1-877-687-7591

Jalapeño and Wild Crab Apple

NET WT. 10 OZ (284g)

6 97373 10204 4

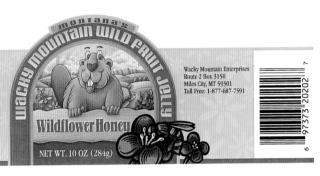

Try Something Wild!

The bees at Wacky Mountain work diligently to bring you the finest wildflower honey under the sun. This rich, full-bodied honey comes straight from the hive with all the nutrients and goodness nature intended! Enjoy.

Ingredients: Pure Wildflower Honey

Wacky Mountain Enterprises
Route 2 Box 3150
Miles City, MT 59301
Toll Free: 1-877-687-7591

Wildflower Honey

NET WT. 10 OZ (284g)

6 97373 20202 7

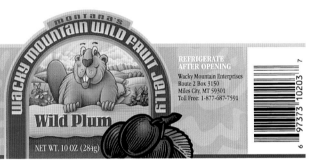

Try Something Wild!

The combination of delicious wild fruits and recipes from Montana's early pioneers gives Wacky Mountain Wild Fruit Jelly a unique flavor you'll go wild over. Our jelly is made in small batches with pure sugar and no additives or artificial coloring. Your toast will never be the same again! Enjoy.

Ingredients: Fruit Juice, Sugar, Pectin

REFRIGERATE AFTER OPENING
Wacky Mountain Enterprises
Route 2 Box 3150
Miles City, MT 59301
Toll Free: 1-877-687-7591

Wild Plum

NET WT. 10 OZ (284g)

6 97373 10203 7

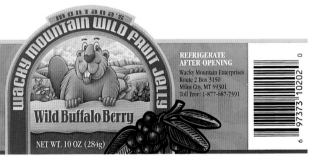

Try Something Wild!

The combination of delicious wild fruits and recipes from Montana's early pioneers gives Wacky Mountain Wild Fruit Jelly a unique flavor you'll go wild over. Our jelly is made in small batches with pure sugar and no additives or artificial coloring. Your toast will never be the same again! Enjoy.

Ingredients: Fruit Juice, Sugar, Pectin

REFRIGERATE AFTER OPENING
Wacky Mountain Enterprises
Route 2 Box 3150
Miles City, MT 59301
Toll Free: 1-877-687-7591

Wild Buffalo Berry

NET WT. 10 OZ (284g)

6 97373 10202 0

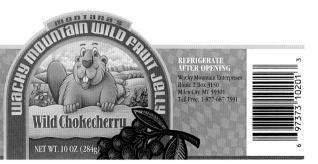

Try Something Wild!

The combination of delicious wild fruits and recipes from Montana's early pioneers gives Wacky Mountain Wild Fruit Jelly a unique flavor you'll go wild over. Our jelly is made in small batches with pure sugar and no additives or artificial coloring. Your toast will never be the same again! Enjoy.

Ingredients: Fruit Juice, Sugar, Pectin

REFRIGERATE AFTER OPENING
Wacky Mountain Enterprises
Route 2 Box 3150
Miles City, MT 59301
Toll Free: 1-877-687-7591

Wild Chokecherry

NET WT. 10 OZ (284g)

6 97373 10201 3

design firm: LIMA DESIGN
art director: PETER PAUL CURTIS
designers: LISA MCKENNA, MARY KIENE
printer: SHAWMUT PRINTING
paper stock: MACTAC STARLINER
printing: 5 COLORS, OFFSET
dimensions: 1 1/4"
(3.3 CM) SQUARE

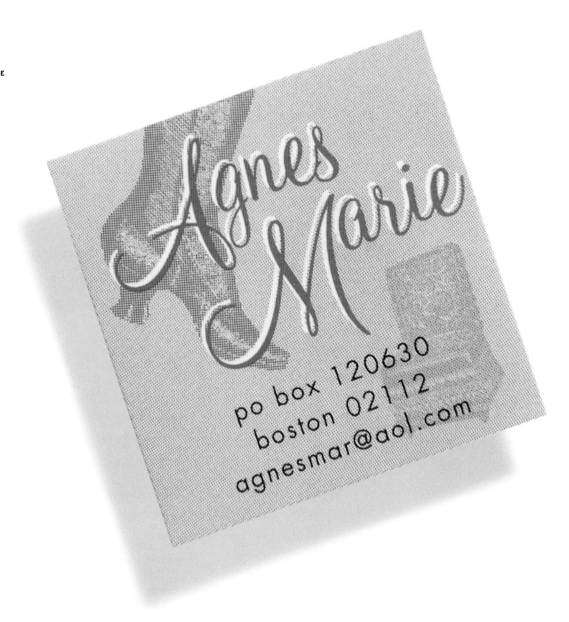

project: AGNES MARIE LOGO STICKER
client: AGNES MARIE

Lima Design built a lot of personality into this tiny label, which is adhered to various Agnes Marie products to carry through the retailer's identity. The distinctive pastel colors and vintage illustrations give it plenty of zing for a piece that is smaller than many postage stamps.

design firm: LIMA DESIGN
art directors: JUSTIN PELUSO, STACY SLANEY
designers: LISA MCKENNA,
MARY KIENE-GUALTIERI
illustrators: SHAWMUT PRINTING
EMPLOYEES' CHILDREN
printer: SHAWMUT PRINTING
paper stock: COVER—CHROMALUX METALLIC
BLUE; TEXT—FOX RIVER CORONADO STIPPLE
printing: 4 COLORS, OFFSET, DIE-CUT
quantity: 800
dimensions: 4 1/2" x 5 1/2"
(11 CM X 14 CM)

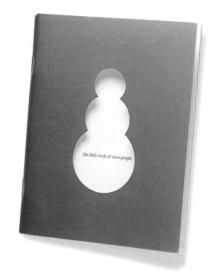

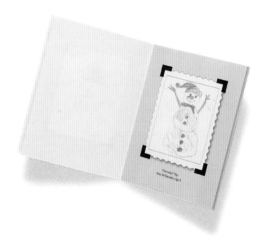

project: *THE LITTLE BOOK OF SNOWPEOPLE* HOLIDAY MAILER
client: SHAWMUT PRINTING

Shawmut Printing involved its employees and their children in the production of their annual holiday greeting card. To create *The Little Book of Snowpeople*, employees invited their children (and even their pets) to provide illustrations of snowpeople and give them names. "The booklet showcases little artists in a little format with big pride!" says designer Mary Kiene-Gualtieri. The biggest challenge? "Ever try to art-direct children?"

design firm: **Format Designgruppe**
designer/illustrator: **Knutt Ettling**
printing: **2 colors, offset**
quantity: **300 of each**
dimensions: **3 1/2" x 2"**
(9 cm x 5 cm)

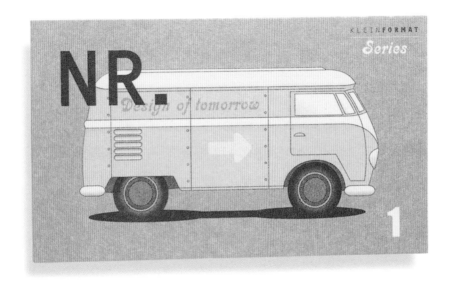

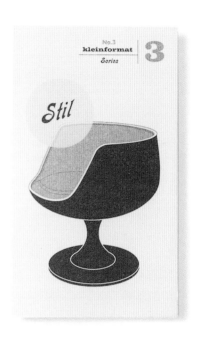

project: **Format Designgruppe "Kleinformat"
Small Art Series**
client: **Format Designgruppe**

Format Designgruppe launched a
numbered small art series, Kleinformat,
with these three pieces, designed with
Format Designgruppe icons and
trimmed to a business card size.

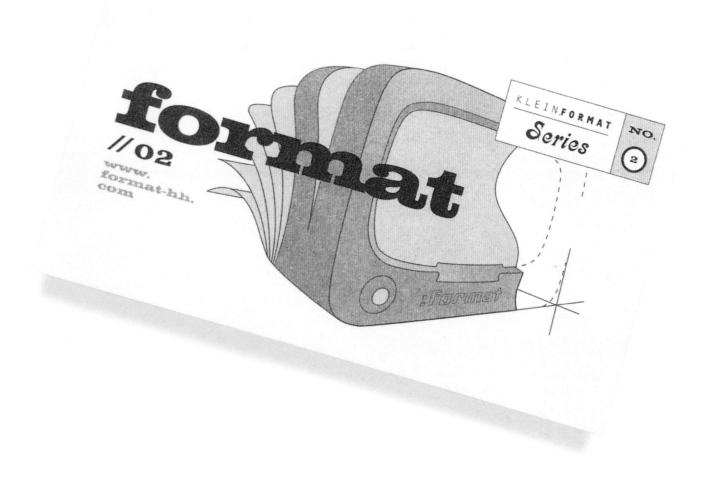

design firm: **FORMAT DESIGNGRUPPE**
designer/illustrator: **KNUTT ETTLING**
printing: **2 COLORS, OFFSET**
quantity: **300 OF EACH**
dimensions: **5 1/2" x 1 1/2"**
(13 CM X 3.5 CM)

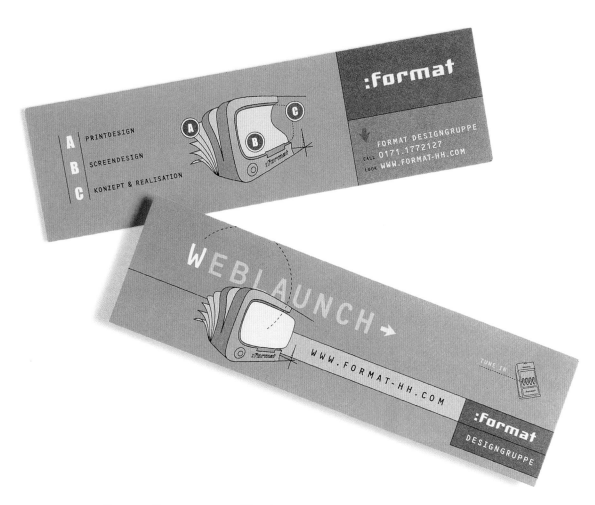

project: **FORMAT DESIGNGRUPPE WEB LAUNCH
AND PROMOTIONAL FLYER**
client: **FORMAT DESIGNGRUPPE**

Format Designgruppe announced
its Web site and the firm's design
capabilities with these illustrated
bookmark-sized flyers. The slim pieces
provide all necessary copy in one
concise graphic element that is easily
and quickly inserted in a letter or
package to get the word out—fast.

design firm: **R2 Design**
art directors/designers: **Lizá Defossez Ramalho, Artur Rebelo**

project: **Rad Bones Logo**
client: **Rad Bones**

Rad Bones, a sportswear company, was in search of a logo that would fit its image, catch the attention of clients and radical sports enthusiasts, and reproduce well on T-shirts and other clothing items. To that end, R2 Design developed this logo to look like animal bones, trembling with movement.

design firm: **Yfactor Inc.**
art director: **Anya Colussio**

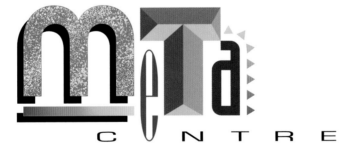

project: **The Meta Centre Logo**
client: **The Meta Centre**

"The Meta Centre, a social-service agency for developmentally challenged adults, needed a logo that was creative, colorful, fun, and expressed everybody's uniqueness," says Anthony Lucic, Yfactor Inc. To meet these needs, Yfactor mixed different type styles, colors, and textures to express the individuality of the center's participants. "It invites the viewer to learn more about the center, while retaining a strong level of sophistication," adds Lucic.

design firm: GIG DESIGN
art director/designer/illustrator: LARIMIE GARCIA
printer: LOGIN, WOOD & JONES
printing: 2 COLORS AND FOIL OVER 1, SHEETFED
quantity: 1,000
dimensions: 1 1/2" x 3 1/2"
(4 CM X 9 CM)

project: GIG DESIGN BUSINESS CARD
client: GIG DESIGN

The smaller-than-usual size of the
business card and its black, foiled logo
characterize this calling card for Gig
Design. Opting for black foil over ink
sharpens the contrast and distinguishes
this card from other one-color renderings.

design firm: João Machado Design, Lda
art director/designer/illustrator: João Machado
paper stock: Retreve Earthtints Concha
280 g/m2
printing: 4 colors, offset
quantity: 500
dimensions: 5" x 10 1/4"
(13 cm x 26 cm)

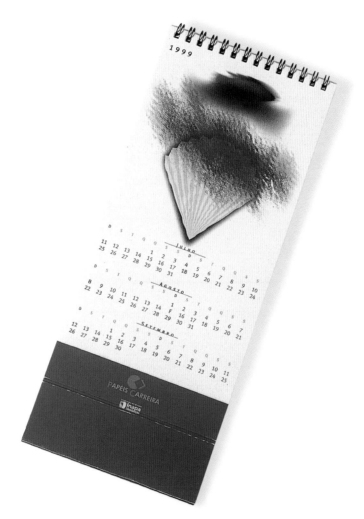

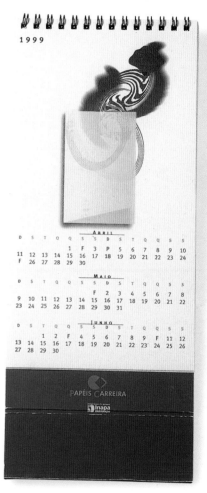

project: Papéis Carreira Calendar
client: Papéis Carreira, Lda

Among all of its promotions, Papéis Carreira, Lda, a paper manufacturer, publishes an annual calendar to showcase its papers and printability. For the 1999 edition, João Machado created a calendar with a series of elegant illustrations, colored with a palette of rich jewel tones. The prominent illustrations, while only half the size of this desktop calendar, appear much larger due to the dramatic choice of colors.

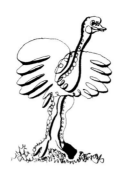

Caroline DeVita

853 21st Street Unit D Santa Monica California 90403
phone: 310.586.0026 fax: 310.829.5917

design firm: CAROLINE DEVITA
GRAPHIC DESIGN & ILLUSTRATION
art director/designer/illustrator:
CAROLINE DEVITA
printing: 1 COLOR
quantity: 500
dimensions: 3 1/2" x 2"
(9 CM X 5 CM)

project: CAROLINE DEVITA GRAPHIC DESIGN & ILLUSTRATION LOGO
client: CAROLINE DEVITA GRAPHIC DESIGN & ILLUSTRATION

Illustrator and designer Caroline DeVita chose an ostrich to represent her business because "it is graceful with a touch of awkwardness at the same time," she says. DeVita wrote the letterforms by hand to match the style of the drawing and used a quill pen for both the lettering and illustration. "I thought that the playfulness of the illustration, as well as the intricacy and detail of the lines, were good examples of my illustration style. The size of the ostrich on the business card is only about half the size of the original, but I had no problem with the thin lines holding together when the logo was reduced." A second version of the ostrich with its head in the sand adorns DeVita's past-due letterhead with the hand-rendered caption, "You can't hide from me!"

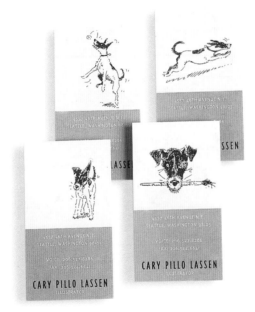

design firm: BELYEA
art director: PATRICIA BELYEA
designer: TIM RUZEL
illustrator: CARY PILLO LASSEN
printer: TILIKUM PLACE PRINTERS
paper stock: FRENCH DURO-O-TOME
BUTCHER OFF-WHITE 80 LB. COVER
printing: 2 COLORS, OFFSET
quantity: 500
dimensions: 2" x 3 1/2"
(5 CM X 9 CM)

project: CARY PILLO LASSEN BUSINESS CARDS
client: CARY PILLO LASSEN

Belyea incorporated four different illustrations by Cary Pillo Lassen in her business cards. They provide the requisite address and contact numbers while showcasing her illustrative style. The illustrations are also evidence of Lassen's sense of humor. They are large enough to fully demonstrate her skill without crowding out the necessary copy. "The variety of cards and illustrations let Lassen show more of her work, enhancing her business," says Patricia Belyea.

design firm: BELYEA
art director: PATRICIA BELYEA
designer: RON LARS HANSEN
illustrator: ROBERT CRAWFORD
printer: TROJAN LITHO
paper stock: CARD STOCK 8 PT.
printing: 4 COLOR PROCESS OVER 1,
SHEETFED, DIE-CUT AND SCORED
quantity: 63,000
dimensions: 3 1/8" x 6 1/4"
(8 CM X 16 CM)

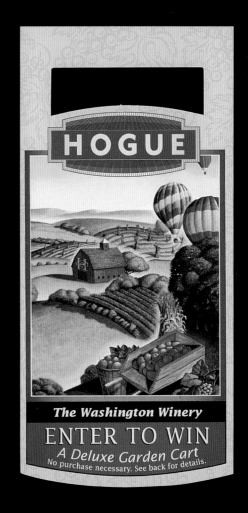

project: HOGUE WINE NECKERS
client: VINTAGE NEW WORLD

Belyea's charter was to create an appealing point-of-purchase campaign for Hogue Wine that would attract consumers. The illustration is the focal point and it is drawn in a warm, autumnal color palette, depicting what one would imagine is a day at Hogue—rolling hills, traditional red barn, blue skies, hot air balloons, and a thriving vineyard. Surprisingly, despite the very limited space, the illustrator has painted a full and visually satisfying picture of Hogue that catches the eye and entices consumers to read about the "Enter to Win" contest.

design firm: ANA COUTO DESIGN
creative director: ANA COUTO
designers: ANA COUTO, CRISTIANA
NOGUEIRA, NATASCHA BRASIL,
JAQUELINE FERNANDES
illustrators/artists: ELIZABETH ROSEN,
RUSSEL O. JONES, TIM HUSSEY,
BEPPE GIACOBBE, GINA BINKLEY
printers: CIGARETTE PACKS—SOUZA CRUZ;
POSTCARDS—DRQ GRÁFICA E EDITORA
paper stock: POSTCARDS—SUPREME
CARDBOARD 250 G/M2
printing: PACKS—5-COLORS, OFFSET;
POSTCARDS—4 OVER 2, OFFSET
print quantity: PACKS—50,000;
POSTCARDS—48,000 OF EACH
dimensions: PACKS—
2 1/8" x 3 1/2" x 7/8"
(5.5 CM x 8.7 CM x 2.2 CM)
POSTCARDS—6 1/2" x 4 3/4"
(17 CM x 12 CM)

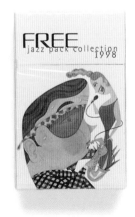 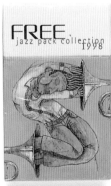 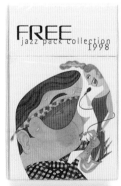 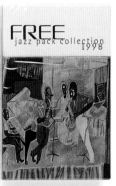

project: **FREE JAZZ FESTIVAL 1998
LIMITED-EDITION PACKS AND POSTCARDS**
clients: **SOUZA CRUZ AND STANDARD, OGILVY & MATHER**

Free, a well-known cigarette brand in Brazil, sponsors the annual Free Jazz Festival. To strengthen the brand, promote the festival, and most importantly, emphasize the Free brand's affiliation with the event, Ana Couto Design decided to use the most logical vehicle to promote the tie-in—the cigarette packaging itself. Designers dressed up the packs, creating limited-edition packaging available only prior to and at the event. Five artists illustrated and signed the packs with their own interpretation of the jazz world. Their artwork was reduced to fit on the small packs, while a slightly larger version of each illustration was used on postcards, which were given away as an additional promotional vehicle.

design firm: MERYL POLLEN
art director/designer/illustrator: MERYL POLLEN
printer: LOGIN, WOOD & JONES
paper stock: STARWHITE VICKSBURG VELLUM
TIARA WHITE AND NATURAL WHITE
printing: 1 COLOR, ROUNDED CORNERS, OFFSET
quantity: OPEN CARD—4,000
SALE CARD—2,500

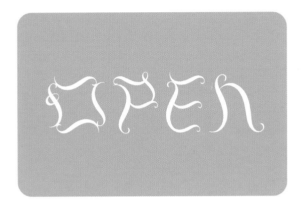

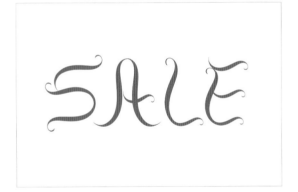

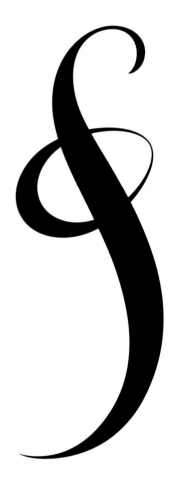

project: SUZANNE FELSEN JEWELRY POSTCARDS
client: SUZANNE FELSEN

To produce distinctive "Open" and "Sale" postcards for a jewelry retailer, Meryl Pollen used the logo she created for her client as the basis for a new type font. "The goal for the opening announcement was to find a way to reference past invitations without using an image of the jewelry," Pollen explains. "The logo was the one universal object, and its main form, with almost no manipulation of the original, worked nicely to create a font." Once Pollen established the letterform for the "Open" postcard, it was easy to carry the concept through to other collateral pieces as well, including a postcard notifying recipients to special sales events.

design firm: GRETEMAN GROUP
art director: SONIA GRETEMAN
designer: JAMES STRANGE
printer: RAND GRAPHICS
paper stock: NEENAH CLASSIC COLUMNS
printing: 2 COLORS, OFFSET
dimensions: 3 1/2" x 2"
(9 CM X 5 CM)

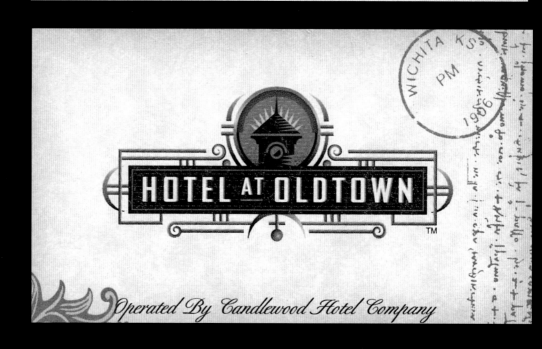

830 EAST FIRST · WICHITA, KS 67202

Tel 316-267-4800 · Fax 316-267-4840

RESERVATIONS 888-CANDLEWOOD EXT. 521222

WWW.HOTELATOLDTOWN.COM

William Bradley Dew GENERAL MANAGER

Delivering Exceptional Value®

HOTEL AT OLDTOWN™

Operated By Candlewood Hotel Company

project: HOTEL AT OLD TOWN BUSINESS CARD
client: HOTEL AT OLD TOWN

In the small space of a business card, designers perfectly blend several elements to create a feeling of nostalgia in keeping with ambiance inspired by the Hotel at Old Town, an upscale hotel in a renovated 100-year-old warehouse in the heart of Wichita, Kansas's historic red brick district. A retro typeface that forms the logo, vintage scrollwork, handwriting reminiscent of that found on an old postcard, and a cancellation mark dated 1906 combine with the aged look of the card to give it its unique appeal.

design firm: **Hornall Anderson**
Design Works, Inc.
art directors: **Jack Anderson,**
Jana Nishi
designers: **Jack Anderson, Jana Nishi,**
Heidi Favour, David Bates, Mary Hermes
illustrators: **Julia LaPine, Jana Nishi,**
Dave Julian
printer: **Frankston Paperbox**
paper stock: **Box stock**
printing: **5 colors and varnish**
dimensions: **1 3/4" x 3"**
(4 cm x 8 cm)

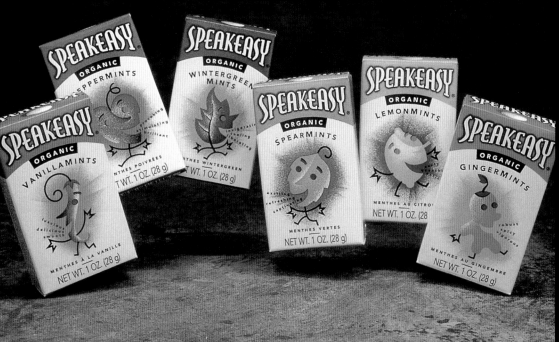

WE CAN DO NO GREAT THINGS; ONLY SMALL THINGS WITH GREAT LOVE. —Mother Teresa

By definition, minimalist is spare and clean. At the opposite end of the spectrum is baroque with its lavish, elaborate, often over-the-top, gold and jewel-toned pageantry.
We find minimalist expression and styling in all things: writing (both poetry and prose), architecture, jewelry, furniture, décor, music, and of course, art. Paintings and sculptures hearken to the minimalist style, as does graphic design.

Minimalist styling is often a design choice, but when small canvases are the medium, then minimalist design often becomes a necessity, not an option. When space is at a premium, it makes sense to keep the design clean and forthright. There isn't any space to waste. There is no room for verbose graphics or words. Instead, graphics and copy must communicate concisely and get right to the point without losing their depth and composition.

How do you manage to retain the best of both worlds—clean, spare design that is also multidimensional, intriguing, and visually compelling? Some designers have discovered the magic of one color—cleverly avoiding the boredom typically associated with one-color jobs. Daring die-cuts provide another solution. Unusual type choices and simple imagery also provide design solutions when minimalist styling is used to achieve maximum impact.

F

design firm: SAGMEISTER INC.
art director: STEFAN SAGMEISTER
designers: STEFAN SAGMEISTER, VERONICA OH
illustrators: ERIC SANTO, VERONICA OH,
STEFAN SAGMEISTER
paper stock: MATTE LAMINATED GLOSS
100 LB. COVER
printing: 1 COLOR
quantity: 10,000
dimensions: 5 3/4" x 5 3/4"
(14.5 CM x 14.5 CM)

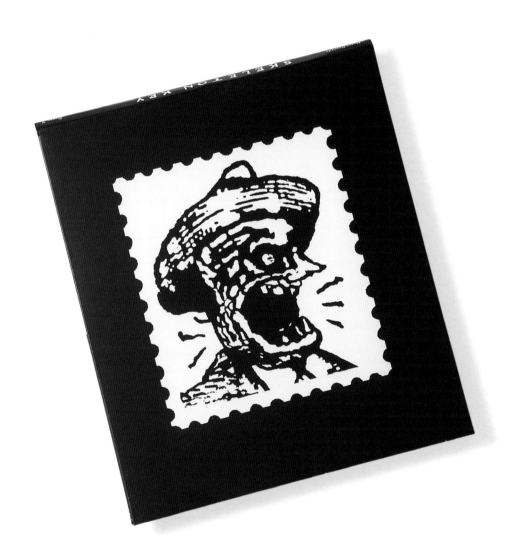

project: SKELETON KEY EP
client: MOTEL RECORDS

The client provided Stefan Sagmeister
the stamp illustration for this CD
jacket. Since there wasn't the time or
budget to dress it up, the designers
opted to cut it up, enlarge it, and add
some illustrations behind it. The result
is a quirky one-color CD jacket printed
with two hits of black.

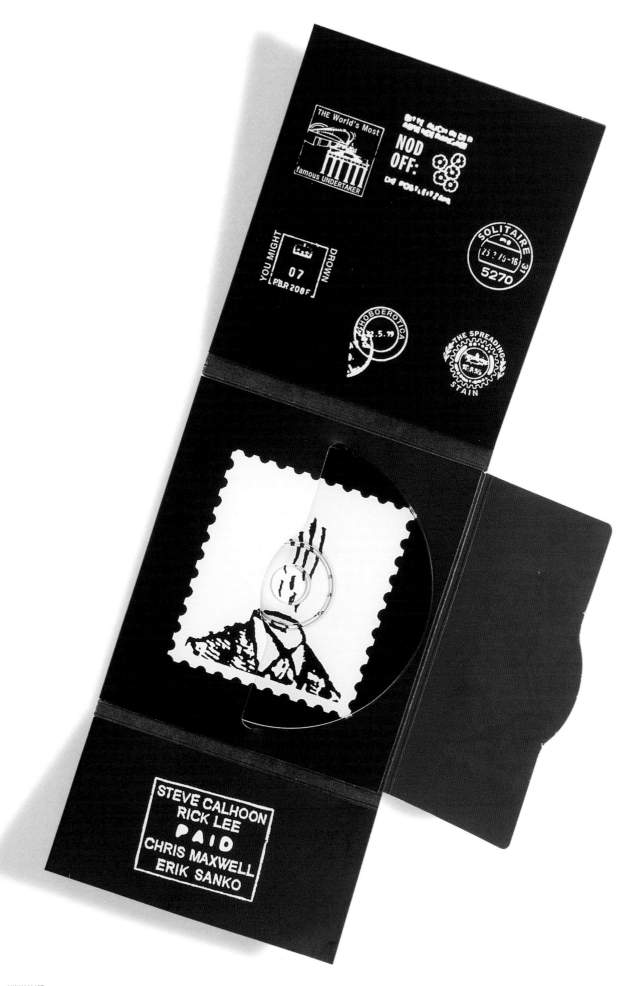

design firm: BASE ART COMPANY
art director/designer: TERRY ALAN ROHRBACH
copywriter: KAREN ROHRBACH
production assistant: JESSE BULGER
printer: IN-HOUSE
paper stock: ARCHES WATERCOLOR PAPER,
ASSORTED JAPANESE PAPERS
printing: 4 COLOR PROCESS, INK JET
quantity: 100
dimensions: 5" X 6 1/2"
(13 CM X 17 CM)

project: BASE ART COMPANY'S "A NOVEL IDEA" BROCHURE
client: BASE ART COMPANY

Base Art Company's goal was to market its design services for book jackets to publishers. The resulting self-promotion brochure, "A Novel Idea," packages the firm's capabilities in book form as a page-turning read.

The characters include Base Art Company and its prospects. The firm's work is showcased as thumbnail photographs adhered to actual pages taken from classic paperback novels.

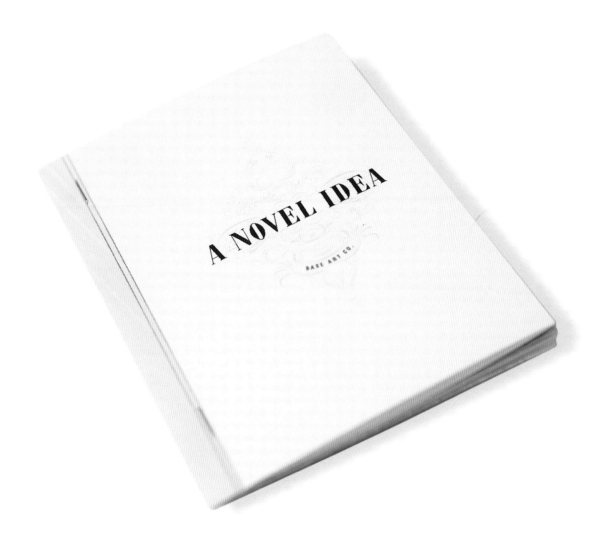

design firm: Oh Boy, A Design Company
art director: David Salanitro
designer: Alice Change
photographer: Hunter L. Wimmer,
PhotoDisc, Inc., Nonstock, Inc.
printer: Expressions Lithography
paper stock: Mohawk Superfine
Ultrawhite Smooth 130 lb. cover
printing: 5 colors, offset
quantity: 5,000
dimensions: 1 1/2" x 3 1/2"
(4 cm x 9 cm)

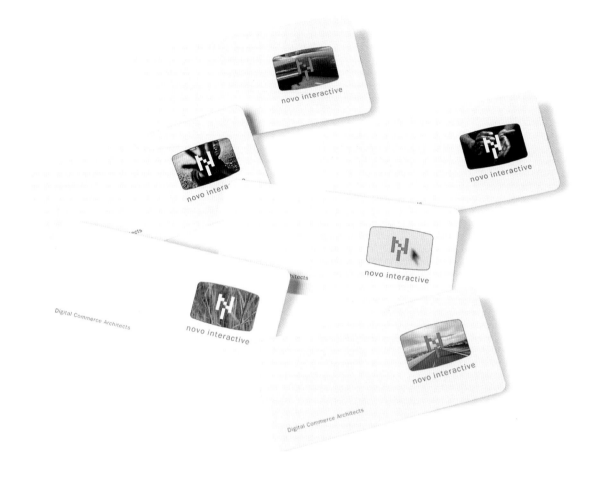

project: Novo Interactive Business Cards
client: Novo Interactive

Oh Boy, A Design Company created a fluid and adaptable identity for Novo Interactive, a company that provides digital commerce solutions to the Internet industry. The pixilated *NI* in the screen-shaped keyline sits amid a stark white card, symbolic of having plenty of room for change. Each employee's card features a different visual, reinforcing the theme that this company is ever-changing to adapt to a fast-evolving industry.

design firm: **Mires Design, Inc.**
art director: **Scott Mires**
designer: **Miguel Perez**
photographer: **Chris Wimpey**
copywriter: **Scott Mires**
printer: **Woods Lithography**
paper stock: **Quintessence**
printing: **2 colors**
dimensions: **2 3/4" x 3"
(7 cm x 8 cm)**

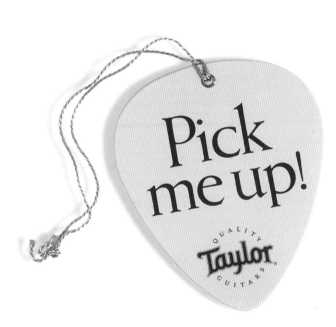

project: **Taylor Guitars "Pick me up!" Hang Tag**
client: **Taylor Guitars**

Using a clever play on words, Mires Design, Inc. created a hang tag for Taylor Guitars that ties into their product and creates a memorable identity—with little copy. According to Scott Mires, the design solution was a natural. "We found that the shape of a guitar pick could easily be used as a hang tag. This shape gave the tag a creative, unique look and helped potential buyers differentiate the special features from other guitars," says Mires. The trickiest part of the project was to keep the tag small, yet powerful, so that it could quickly communicate the guitar's attributes without detracting from its beauty.

design firm: TERRAPIN GRAPHICS
art director/designer/illustrator: JAMES PETERS
supplier: EIVERS PROMOTION PRODUCTS LTD.
imaging: 5 COLORS
print quantity: 2,000
dimensions: 1/4" x 1 1/4"
(.5 CM X 3.5 CM)

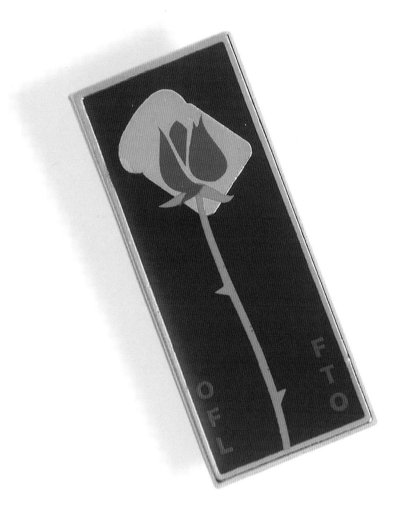

project: *BREAD AND ROSES* LAPEL PIN
client: ONTARIO FEDERATION OF LABOUR, WOMEN'S RIGHTS DEPARTMENT

Designer James Peters integrated the labor song, *Bread and Roses*, originally sung by striking female garment workers in New York City, into a lapel pin to celebrate International Women's Day. Peters had to choose between featuring the "bread and roses" through type or imagery, since the minimal space didn't allow for both. He opted for a striking, yet simple illustration, that was so popular that it has since become a collector's item.

design firm: NIKLAUS TROXLER DESIGN
art director/designer/illustrator: NIKLAUS TROXLER
printing: 3 COLORS
dimensions: 4" X 4 3/4"
(10 CM X 12 CM)

Millennium Kirsch

1999
2000

70 cl 41%vol.

Original Willisauer

project: MILLENNIUM KIRSCH LABEL
client: DIWISA SA, DISTILLERY

Millennium Kirsch, a liqueur that
pays homage to the year 2000,
makes a bold statement with a
minimalist black label dressed up
with gold type and bright red
cherries.

design firm: SHANE LEWIS DESIGN
art director/designer: SHANE LEWIS
printer: BAY TECH LABEL
printing: 2 SPOT COLORS, FLEXOGRAPHY
dimensions: 4" X 1 1/2"
(10 CM X 4 CM)

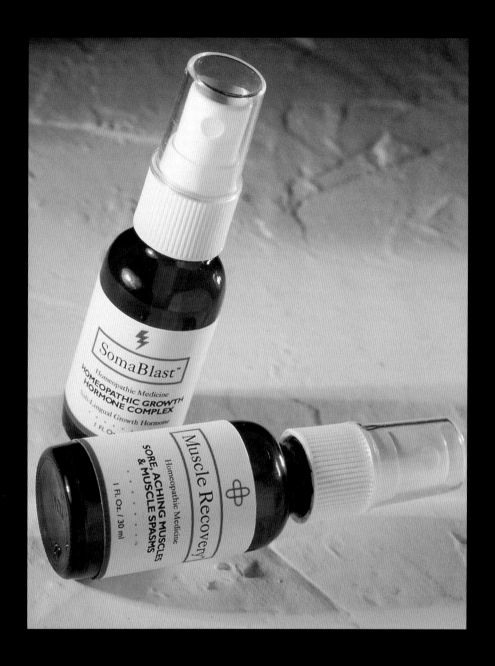

project: BODY LIFE SCIENCES' SOMABLAST AND MUSCLE RECOVERY LABELS
client: BODY LIFE SCIENCES

These tiny, one-ounce bottles of two different growth hormone sprays are treated to a simple, clean label design. Each sports a descriptive icon that reinforces the medicinal effects of the products. The cobalt bottle enlivens the design and is reminiscent of time-honored pharmaceutical product packaging.

design firm: SHANE LEWIS DESIGN
art director/designer/illustrator: SHANE LEWIS
printer: BAY TECH LABEL
printing: 4 COLOR PROCESS, FLEXOGRAPHY
dimensions: 5 1/2" x 3 3/4"
(14 CM X 9.5 CM)

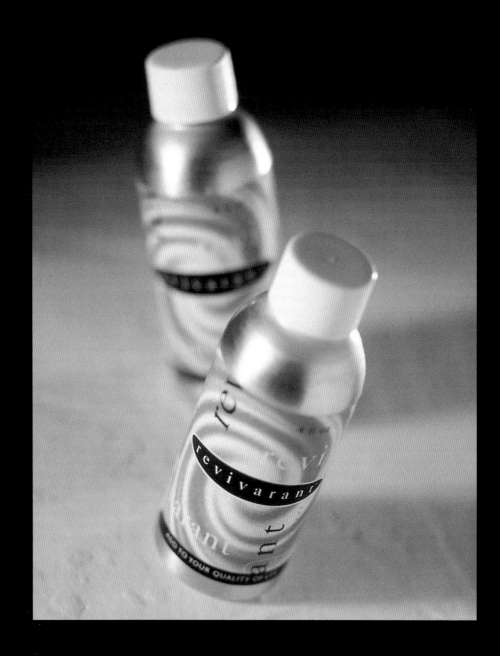

project: **BODY LIFE SCIENCES' REVIVARANT LABEL**
client: **BODY LIFE SCIENCES**

To convey the essence of this sleep rejuvenation product, Shane Lewis designed a visual that would imply a dreamlike state. The combination of a soft color palette and equally soft-edged type is soothing, while the choice of a metallic silver bottle lends subtle impact.

design firm: BÜRO FÜR GESTALTUNG
designers: CHRISTOPH BURQARDT,
ALBRECHT HOTZ
paper stock: WHITE CARD STOCK
printing: 3 COLORS, OFFSET
quantity: 5,000
dimensions: 5 3/4" x 4"
(14.6 CM x 10.2 CM)

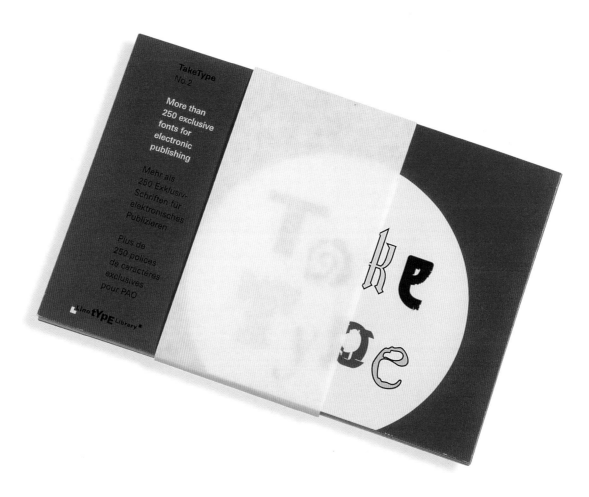

project: LINOTYPE LIBRARY "TAKE TYPE" POSTCARDS
client: LINOTYPE LIBRARY GMBH

Designers developed this series of eighteen postcards, entitled "Take Type," to showcase the vast array of fonts available from Linotype Library GmbH. Rather than list fonts in a lengthy catalog, designers opted to profile selected fonts in a postcard format that would provide a canvas to show the font in use and still be cost-effective. The postcards limit their sales message to the graphically driven front of the card, while the back is devoid of copy except for the Linotype Library address.

design firm: LIKOVNI STUDIO D.O.O.
art director: DANKO JAKSIC
designer: TOMISLAV MRCIC
type director: MLADEN BALOG
printer: KUZMIC PRO
paper stock: MAGNOMATT
printing: 4 COLOR PROCESS, OFFSET
quantity: 500 OF EACH
dimensions: 4" x 2 1/2"
(10 CM X 6 CM)

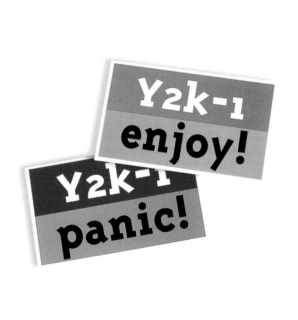

project: LIKOVNI STUDIO Y2K PANIC/ENJOY
POCKET CALENDARS
client: LIKOVNI STUDIO D.O.O.

Likovni Studio poked fun at the two emotional extremes the world population veered between while anticipating the year 2000. While doomsayers proclaimed global panic, the optimists planned lavish millennium parties.

Aside from the obvious collectibility of all things 2000, the pocket calendar had its practical side and worked as a constant reminder of the clever thinking at this studio.

design firm: HOFFMANN & ANGELIC DESIGN
art director/designer: ANDREA HOFFMANN
printer: HEMLOCK PRINTERS
printing: 2 COLORS, OFFSET
dimensions: BUSINESS CARD—
3 1/2" x 2" (9 CM x 5 CM),
10 LB. ENVELOPE
LETTERHEAD—8 1/2" x 11"
(22 CM x 28 CM)

project: THE SELLING EDGE CORPORATE IDENTITY
client: THE SELLING EDGE

The Selling Edge, a small, one-man firm that deals with large multimillion dollar companies, wanted a look that would make the company appear as large as its all-encompassing capabilities. With that objective in mind, Hoffmann & Angelic Design created a powerful, oversized logo in a dynamic purple hue. The logo appears large, even on a small business card, where it is also shown in a screened shade of purple on the reverse. The logo retains its position as the dominant focal point on each subsequent piece of identity material, even the larger pieces.

design firm: CHEN DESIGN ASSOCIATES
art director: JOSHUA C. CHEN
designer: MAX SPECTOR
printer: OSCAR PRINTING COMPANY
paper stock: GLAMA NATURAL CLEAR,
SPLENDORLUX SILVER LASER 80LB COVER
printing: 2 COLORS + FOIL, SHEETFED
quantity: 13,500 (TOTAL OF 6 VERSIONS)
dimensions: 5 1/2" x 8"
(14 CM X 20 CM)

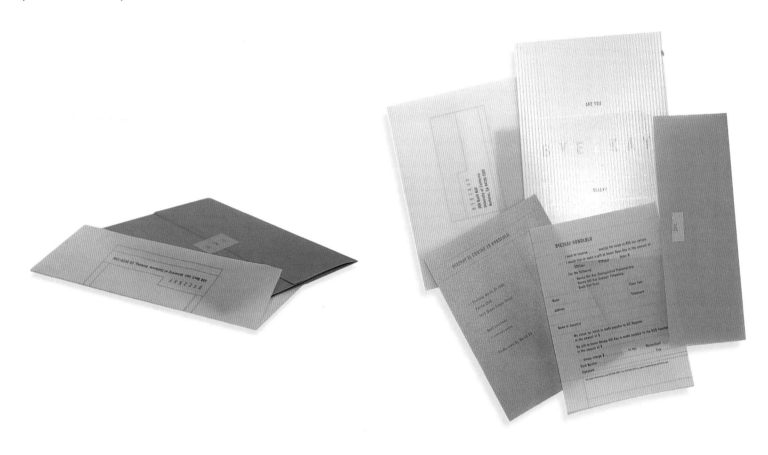

project: **BYE2KAY INVITATION SYSTEM**
client: **BOALT HALL SCHOOL OF LAW, UC BERKELEY**

To celebrate her retirement, the Dean of the U.C. Berkeley Law School, Herma Hill Kay went on a tour of major U.S. cities. The organizers of the BYE2KAY farewell events wanted the invitations to inspire a feeling of looking to the future. To achieve this sensibility, Chen Design Associates let the materials handle the bulk of the conceptual work. The envelopes and reply cards for the piece were printed on translucent paper with metallic inks; the invitation utilized a silver, ridged paper, and foil stamping. These high-profile materials and playful tagline balanced with a minimalist type treatment and layout to create a design both eye-catching and understated.

design firm: CHEN DESIGN ASSOCIATES
art director: JOSHUA C. CHEN
designer: LEON YU
copywriters: JOSHUA C. CHEN,
KATHRYN A. HOFFMAN, LEON YU
printer: OSCAR PRINTING COMPANY
paper stock: FOX RIVER NANTUCKET GRAY
80# COVER
printing: BLACK + PROCESS BLUE, SHEETFED
quantity: 500 OF EACH
dimensions: 3 1/2" x 6"
(9 CM X 15 CM)

project: MOVING CARD
client: CHEN DESIGN ASSOCIATES

Changing offices in San Francisco can cause a great deal of confusion for both a design firm and its clients. With this—and necessary budget constraints in mind—Chen Design Associates produced this pair of minimalist postcards announcing their new studio address. Printed on the same press sheet with the same two inks, they create a very different aesthetic while retaining a visual connection. The flowy, bulbous line drawings and abstract photography reflect the fluid nature of the interpersonal relationships at CDA, and the low-stress approach they take with their clients. Most importantly, both the significance of the message and the inherent nature of the firm are allowed to come through equally.

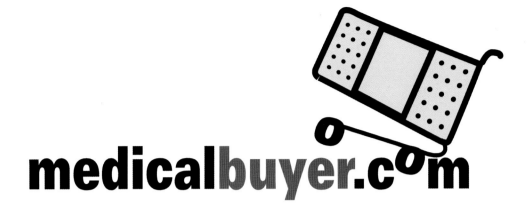

medicalbuyer.com

design firm: LEVEL ONE DESIGN
art director: SUZIE BRICKLEY
designers: SUZIE BRICKLEY,
JENNIFER GIBBS, ELIZABETH HAUTAU
imaging: 3 COLORS

project: **MEDICALBUYER.COM LOGO**
client: **MEDICALBUYER.COM**

To entice customers to buy medical supplies on-line, Level One Design integrated a shopping cart and a Band-Aid™ into a surprisingly simple logo that is also fun and memorable. The lighthanded approach is further emphasized by using one of the shopping cart wheels as the *o* in .com.

TEATRO BRUTO

design firm: R2 DESIGN
art directors/designers: LIZÁ DEFOSSEZ
RAMALHO, ARTUR REBELO
illustrator: LIZÁ DEFOSSEZ RAMALHO
printer: GRECA

project: **TEATRO BRUTO LOGO**
client: **TEATRO BRUTO**

The Teatro Bruto theatrical group is anything but conventional. The troupe can be outlandish and its name, when translated to English, means rude. Realizing that a traditional logotype wouldn't fit the personality of the troupe, R2 Design created an image with rough-hewn letters with irregular edges and haphazard placement of ink. The look is arresting and conveys that an evening with this group isn't your ordinary night at the theater.

design firm: VRONTIKIS DESIGN OFFICE
art director: PETRULA VRONTIKIS
designers: PEGGY WOOL, DAVID SCHWIEGER
printer: WESTLAND GRAPHICS
printing: 2 COLORS, OFFSET
quantity: 1,000,000 OF EACH
dimensions: 1" X 1"
(2.5 CM X 2.5 CM)

project: WARNER/ELEKTRA/ATLANTIC PROMOTIONAL STICKERS
client: WARNER/ELEKTRA/ATLANTIC (WEA)

They are among the most widely
recognized retail symbols — stickers
signifying a value-priced compact
disc. We may take them for granted,
but there aren't many designs that
communicate so much with so little,
and are recognized by so many.

design firm: RULLKÖTTER AGD
art director: DIRK RULLKÖTTER
paper stock: RIVES DESIGN NATUR
printing: 2 COLORS, OFFSET
dimensions: BUSINESS CARD—
3 1/4" x 2 1/4"
(8.5 CM X 5.5 CM)
ENVELOPE—8 1/2" X 4 1/2"
(22 CM X 11 CM)
LETTERHEAD—8 1/2" X 11"
(21 CM X 27.9 CM)

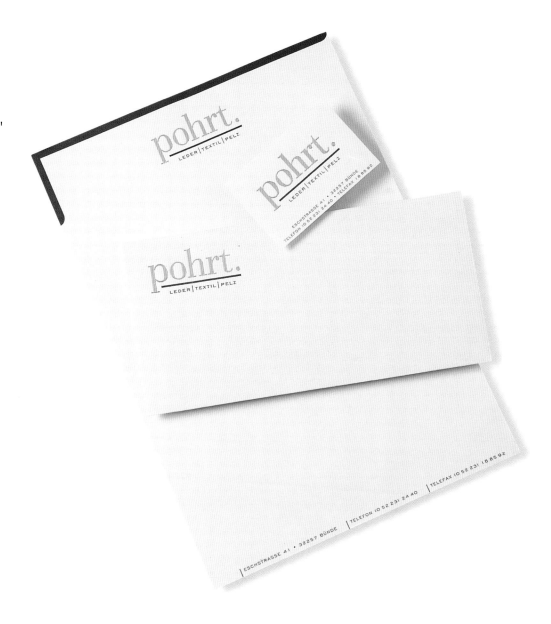

project: **POHRT. CORPORATE IDENTITY**
client: **POHRT.**

Specializing in retailing leather,
textiles, and fur, pohrt's identity
system, as designed by Dirk
Rullkötter, is as upscale and tactile
as its shop and the products it sells.
The lines are clean and simple, yet
the rich paper, choice of type, and
the bold, gold-foil stamped name
say quality.

design firm: GIG DESIGN
art director/designer: LARIMIE GARCIA
printer: LOGIN, WOOD & JONES
paper stock: STRATHMORE ELEMENTS SOFT BLUE
printing: 2 COLORS, OFFSET
quantity: 1,000
dimensions: 3 1/2" x 2"
(9 CM X 5 CM)

tel.fax 209.847.6308

box 1550 oakdale california 95361

LARRY A.GARCIA
LANDSCAPE COMPANY

license no 541688

project: LARRY A. GARCIA LANDSCAPE COMPANY BUSINESS CARD
client: LARRY A. GARCIA

Striving for a contemporary business card design to represent his landscape company, Larry Garcia enlisted Gig Design for help. To elevate the design above the norm, Larimie Garcia based the layout and choice of typography on a horizontal plane to create the feeling of landscape. The blades of grass, appearing almost like a watercolor painting, grow out of the design as the card's one vertical element.

design firm: MIRIELLO GRAFICO, INC.
art director: RON MIRIELLO
designers: CHRIS KEENEY,
COURTNEY MEYER

PALMER | GOLF
BUILT TO HIT IT

project: ARNOLD PALMER LOGO
client: ARNOLD PALMER GOLF

Miriello Grafico was asked to redesign the Arnold Palmer logo, yet keep the emotion and history associated with the name of the famous golf pro. Compounding the challenge was that the logo needed to be flexible enough to be used on products as small as golf club heads and work equally well in large signage applications. To meet these objectives, designers updated and modernized a typeface that they modeled after a 1950s typestyle and added simple graphic shapes.

design firm: MIRIELLO GRAFICO, INC.
art director: RON MIRIELLO
designers: DENNIS GARCIA, CHRIS KEENEY

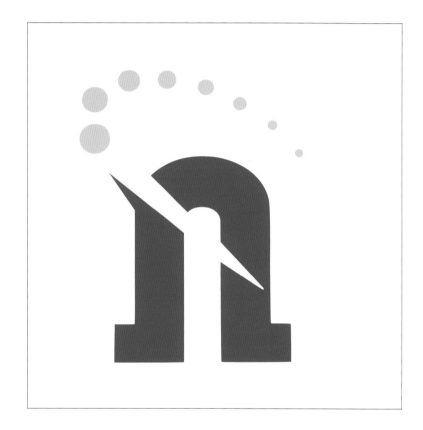

project: **NEWPORT COMMUNICATIONS LOGO**
client: **NEWPORT COMMUNICATIONS**

How do you design a logo that must communicate the image of the company and still work effectively when shrunk down to 1/4" (.5 cm) square? That was the challenge facing designers at Miriello Grafico when asked to create a logo for a company that makes computer chips. "The mark itself needed to project an image of a sophisticated, innovative player in a growing market. It also needed to convey solidity as opposed to being brash or flippant," says Ron Miriello. To meet these objectives, designers created a no-frills logo that simply illustrates the process that converts a noisy signal into a larger digital signal with the dots above the *n* indicating movement and speed. The logo, used throughout the identity in color, was also minimized to 1/4" (.5 cm) square and etched onto a computer chip.

design firm: DEREK DALTON DESIGN
art director/designer/illustrator: DEREK DALTON
printer: MATRIX GRAPHICS
paper stock: STRATHMORE WRITING 80 LB. COVER
printing: 1 COLOR, OFFSET
quantity: 500
dimensions: 3 1/2" x 2"
(9 CM X 5 CM)

Leonard Stein President

Visibility, Inc. Public Relations
Tel 212.777.4350 Fax 212.777.5497 Modem 212.777.5839
611 Broadway, New York, NY 10012

project: VISIBILITY, INC. BUSINESS CARD
client: VISIBILITY, INC.

One word says it all on this business card, where the lack of clarity is its winning asset. Derek Dalton was asked to create a striking graphic identity for Visibility, a public-relations firm.

The firm's name says exactly what it does, so Dalton made optimum use of the play on words. His unique treatment represents the epitome of simplicity with tremendous visual impact.

design firm: MERYL POLLEN
art director/designer: MERYL POLLEN
printer: LOGIN, WOOD & JONES
paper stock: CRANES CREST FLUORESCENT
WHITE WOVE
printing: 2 COLORS (BLACK AND METALLIC
BROWN), OFFSET
quantity: 2,000

425 GRAND BLVD VENICE CA 90291
PH 310 396.2703 FAX 310 452.1482
thewolfgang@earthlink.net

LAURENCE VITTES

THE WOLFgANG

project: **THE WOLFGANG IDENTITY SYSTEM**
client: **THE WOLFGANG (LAWRENCE VITTES)**

Although detailed, this identity for The Wolfgang, a company that provides support to the classical-music industry, gains its impact from a simple combination of letterforms with a flourish. Lawrence Vittes, founder of The Wolfgang, chose the name to reference Wolfgang Amadeus Mozart, his favorite composer, and the concept of a group of experts working together to solve a problem. In creating the identity, Meryl Pollen chose to combine and emphasize the *W* of Wolfgang and the *M* of Mozart "to create a sense of motion through the idea of the composer's notations," Pollen says.

design firm: HORNALL ANDERSON
DESIGN WORKS, INC.
art director: JACK ANDERSON
designers: JACK ANDERSON, LISA CERVENY,
JANA WILSON ESSER, NICOLE BLOSS
illustrators: JANA WILSON ESSER,
NICOLE BLOSS
paper stock: LABEL STOCK, BROWN KRAFT BAGS
dimensions: 1" x 1"
(2.5 CM x 2.5 CM) SQUARE

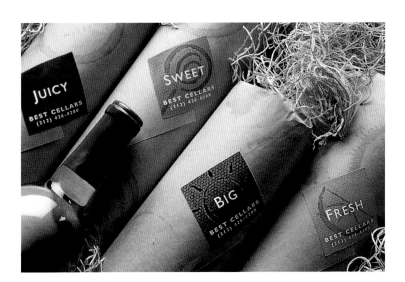

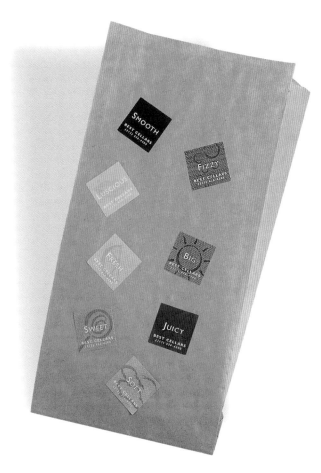

project: **BEST CELLARS STICKERS**
client: **BEST CELLARS**

Best Cellars, a wine distributor and reseller, needed a graphic treatment for its New York flagship store that would convey affordability (wines priced at $10 and under) without compromising taste. Because Best Cellars's logo uses a C-shaped ring—the kind that occurs on a tablecloth after a bottle of wine has been poured—to represent the *C* in Cellars, the wine-stain visual was carried through to the store's packaging.

Designers developed a series of eight metaphoric icons, using the wine-stain treatment, to represent different categories of wine—bubbles for fizzy, clouds for soft, cherries for juicy, etc. These spare, yet deliciously graphic icons were reproduced as 1" (2.5 cm) square labels to dress up brown kraft packaging. They worked equally well when enlarged to a sizable 30" (76 cm) square wayfinding store signage that indicates wine categories.

design firm: **Lewis Moberly**
art director: **Mary Lewis**
designer: **Joanne Smith**
printing: **6 colors, lithography**
dimensons: **3 3/4" x 5"**
(9.5 cm x 12.7 cm)

FINCA FLICHMAN
WINERY

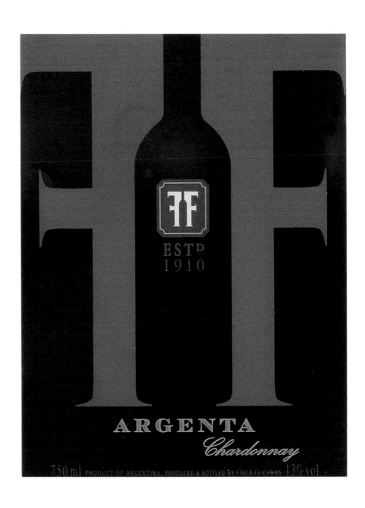

project: **Finca Flichman Logo and Packaging**
client: **Finca Flichman**

Finca Flichman, an Argentinean wine producer, wanted a new identity and package design for the company's branded wines that would project confidence and effectively position the winery as a maker of interesting, quality products. Using the winery's initials, two *F*s, as the primary visual,

Lewis Moberly created a mark that is distinctive—and interestingly, forms a shape of a bottle between their profiles. When the logo is adapted to the bottle's label, the brand is amplified even further. The appearance is prestigious, easily recognizable, and yet, spare.

SMALL PROJECTS NEED MUCH MORE HELP THAN GREAT.
—Dante

Of the hundreds and hundreds of designs reviewed during the compilation of this book, small graphics that make great use of photography were the most rare. Perhaps it's because of the skill and innate design intuition required to know how best to properly showcase a photograph when there is little or no space to display it.

This photography is not exhibited on vast, white museum walls. Instead, many of the photos are shrunk to fit on a canvas the size of a business card or, smaller yet, a postage stamp. Despite the size of the photograph, one is amazed at the attention to detail and enhancements.

Virtually every photographic treatment possible on a large scale is equally achievable in miniature. There are no rules for using color or black-and-white photography; no limits as to how many photos can be layered in a collage the size of a credit card. Behind many of these designs are numerous hours spent at the computer layering, retouching, and enhancing each image to complement its small scale—a meticulous attention to detail of which even the smallest project is worthy. No one will ever know how many hours went into these projects, but it is indisputable that the time was well spent.

design firm: Terrapin Graphics
art director/designer/photographer: James Peters
printer: JBM Resource Network
paper stock: San Remo Gloss 10 pt.
printing: 4-color process, sheetfed
quantity: 1,000
dimensions: 5" x 6"
(13 cm x 15 cm)

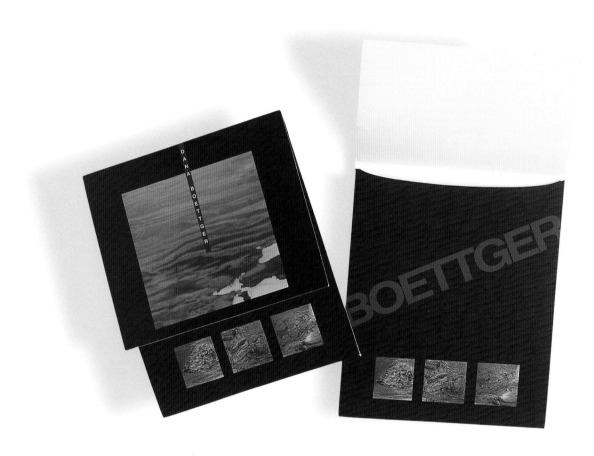

project: Dana Boettger Presentation Envelope
client: Dana Boettger

Painter Dana Boettger fills this envelope with information on herself, her paintings, and prices, and leaves them at the door of galleries exhibiting her work for visitors to take. The artwork on the envelope is one of Boettger's works, photographed in four pieces. Since so much information is tucked inside the envelope, James Peters kept the balance of the design clean so as not to detract from her photographic work.

design firm: 5D STUDIO
art director/designer: JANE KOBAYASHI
photographer: SATUSHI
copywriter: RICHARD FRINIER
printer: GEORGE RICE & SONS
paper stock: KING JAMES C1S 10 PT.
printing: 4 COLORS AND VARNISH, SHEETFED
quantity: 20,000 EACH OF 3
dimensions: 6" X 4 1/4"
(15 CM X 11 CM)

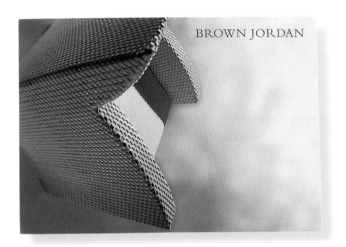

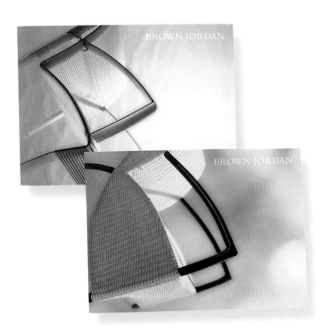

project: **BROWN JORDAN 2000 POSTCARDS**
client: **BROWN JORDAN**

To reflect the modern lines of Brown Jordan's new outdoor furniture, as well as the products' water-related theme—colors and finishes were called spa, pool, and sun—Jane Kobayashi hired a photographer who was adept at combining product with mood. Backgrounds emphasizing the water theme were captured and then integrated with the product shots "in a way that makes it hard to tell they weren't all shot together," says Kobayashi.

design firm: JOÃO MACHADO DESIGN, LDA
art director/designer/illustrator:
JOÃO MACHADO
copywriter: JOÃO MACHADO
printer: LITHOGRAFIA MAIA
printing: 4 COLORS, OFFSET
dimensions: 3 1/8" x 1 1/4"
(8 CM X 3 CM)

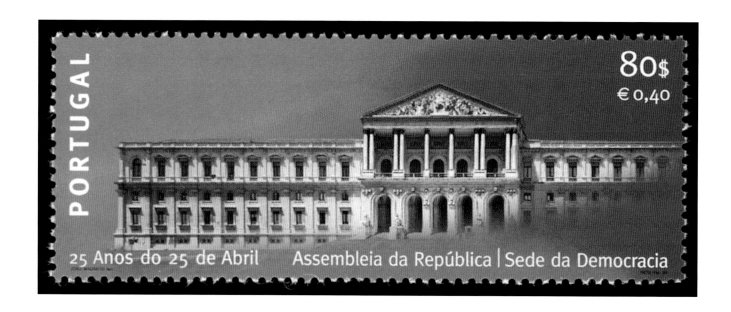

project: **25TH ANNIVERSARY OF THE REVOLUTION OF APRIL 25,
1974, PORTUGESE STAMP**
client: **CTT—PORTUGUESE POST OFFICE**

Designer João Machado has been developing a series of stamps for the Portuguese post office, CTT, so he's accustomed to working with small-format design, but getting the image right can be more complex. This particular stamp was created to commemorate the twenty-fifth anniversary of the Portuguese

Revolution in 1974. Machado chose this building as the graphic because it represents the Portuguese Parliament, where the interests of the people are priority. Machado worked out the details of the image in Adobe Photoshop, and finally, brought it into the main document, which was created in Macromedia Freehand.

design firm: **FORMGEFÜHL**
art director/designer/illustrator: **MARIUS FAHRNER**
printing: **2 COLORS, OFFSET**
quantity: **2,500**
dimensions: **BUSINESS CARD AND LOGO**
CARD—3 3/4" X 2"
(9.5 CM X 5 CM)
BROCHURE—6" X 3 1/2"
(15 CM X 9 CM)

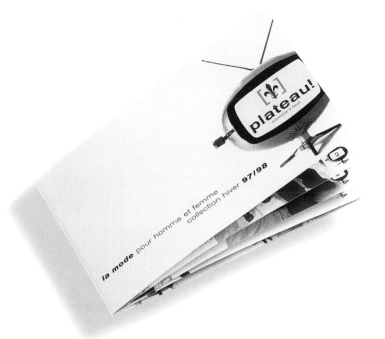

project: **PLATEAU! CORPORATE IDENTITY MATERIALS**
client: **PLATEAU!**

Plateau!, a fashion retailer of French and English haute couture, makes a bold statement with this corporate identity that relies on a soft blue color palette, which is accented by trendy, cutting-edge photography. The models are ethnically diverse, young, fashion-forward Generation Xers. Plateau! is definitely not traditional haute couture.

design firm: DAVID LLOYD BECK
art director/designer/photographer:
DAVID LLOYD BECK
printer: MONARCH PRESS
paper stock: MOHAWK SUPERFINE COVER
printing: 2 COLORS (BLACK AND MATCH
GREEN) OVER 1, SHEETFED
quantity: 250 OF EACH
dimension: 3 1/2" x 2"
(9 CM X 5 CM)

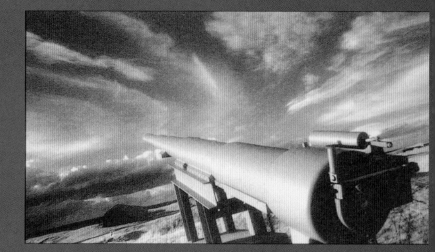

THE CLIFFS AT POINTE DU HOC

from the series

NORMANDIE: 50EME ANNIVERSAIRE DU DEBARQUEMENT

photographs by

DAVID LLOYD BECK

6229 BELMONT AVENUE, DALLAS, TX 75214

214.828.9622

project: "NORMANDY, 50TH ANNIVERSARY" AND "INCIDENTS OF
TRAVEL IN CENTRAL AMERICA" SMALL PHOTO
PORTFOLIO
client: DAVID LLOYD BECK

David Lloyd Beck, a designer who is also a skilled photographer, created a small business-card-sized portfolio from two personal photography projects: "Normandy, 50th Anniversary" and "Incidents of Travel in Central America." He chose four photos from each collection, sized the images to fit a business card, and reproduced them as duotones, using black and a match green. The reverse of the cards identifies the photo and provides Beck's contact information. Where traditional photography portfolios are large and often cumbersome to display, the smallness of this presentation is extremely facile.

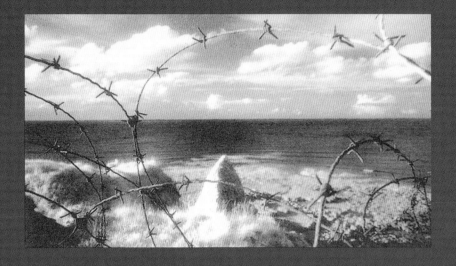

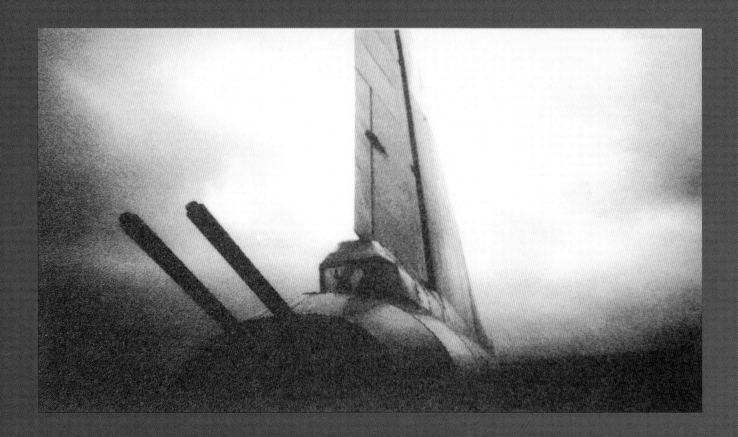

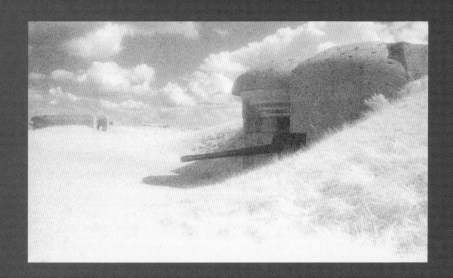

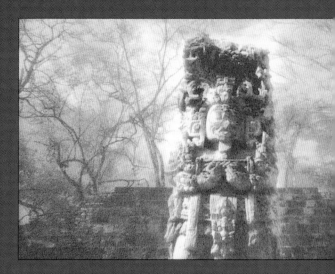

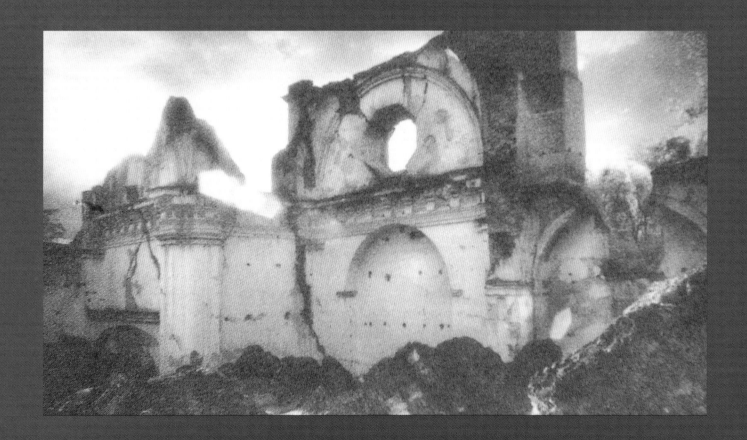

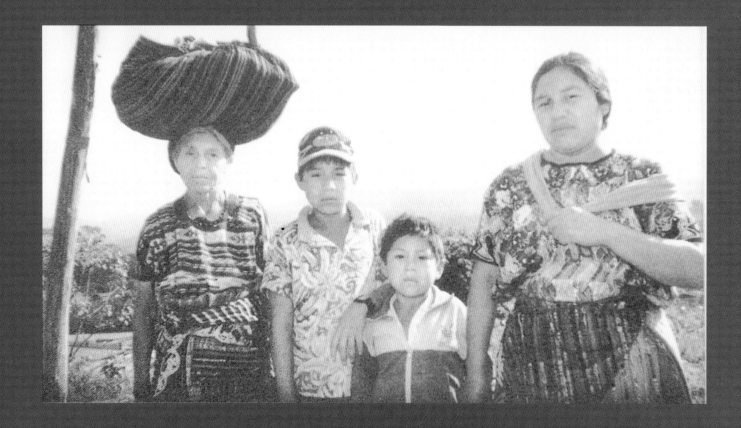

design firm: LEVEL ONE DESIGN
art director/designer: JENNIFER GIBBS
photographer: ALLEN MATTHEWS
printing: STATIONERY—3 COLORS; WINE
LABEL—4-COLOR PROCESS PLUS METALLIC
GOLD AND BURGUNDY FOIL

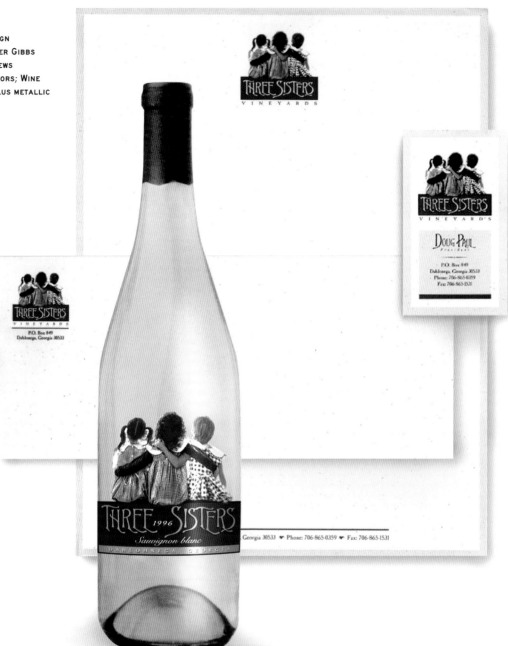

project: **THREE SISTERS VINEYARDS CORPORATE IDENTITY**
client: **THREE SISTERS VINEYARDS**

The Three Sisters Vineyards get its name and imagery from its location in the North Georgia Mountains, where the vineyards overlook the Three Sisters Mountains. The photography of three little girls, arms entwined, is nostalgic, quaint, and warm, complemented by the perfect choice of typestyle. The logo is also wonderfully different, textured, and rich in color. For all these reasons, it differentiates itself from traditional wine packaging.

design firm: **LIEBER BREWSTER DESIGN, INC.**
art director: **ANNA LIEBER**
copywriter: **LAURA LOBDELL**
photographer: **ANTON GINZBURG**
(**CDOT PRODUCTIONS**)
printing: **4-COLOR PROCESS**
quantity: **2,000**
dimensions: **4 1/4" x 6"**
(10.5 CM X 15 CM)

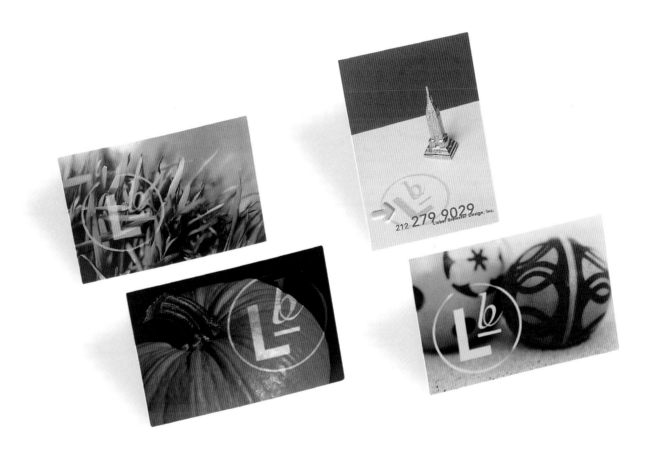

project: **LIEBER BREWSTER DESIGN, INC. SEASONAL
PROMOTIONAL POSTCARD CAMPAIGN**
client: **LIEBER BREWSTER DESIGN, INC.**

Lieber Brewster Design's seasonal postcard mailer combines photography with short, soft-sell copy that gets right to the point. One might wonder about the reasoning behind a photograph of a pumpkin, highlighted with a glowing rendition of the Lieber Brewster logo, until the reader turns the postcard over and reads the copy: "Some people see a pumpkin; we see a ride to the prince's ball." That's the kind of thinking a client wants in a design firm.

design firm: ORANGE
art director/designer: SUSAN LEE
photography: STOCK
paper stock: POTLATCH MCCOY MATTE
100 LB. COVER
printing: 4-COLOR PROCESS, SHEETFED
quantity: 500
dimensions: 2" x 3 1/2"
(5 CM X 9 CM)

Susan Lee / Wedding Photography / 604.728.9269

project: SUSAN LEE WEDDING PHOTOGRAPHY BUSINESS CARDS
client: SUSAN LEE WEDDING PHOTOGRAPHY

When Susan Lee isn't running Orange, her design firm, she fills her hours as a wedding photographer with a twist—her images have a retro feel. To communicate her approach to prospective clients, she designed her card using stock photos of bride and groom wedding cake figures, graduated in size, as the focal graphic on a blanket of white. The card leaves no doubt about her profession and promises that her photographs will be beyond the norm.

design firm: **Addison**
art director/designer/photographer:
Leslie Segal
printer: **Kaplan**
paper stock: **Champion Kromekote**
Recycled C1S
printing: **1 color**
quantity: **1,000**
dimensions: **2 1/16" x 3 3/8"**
(5 cm x 8 cm)

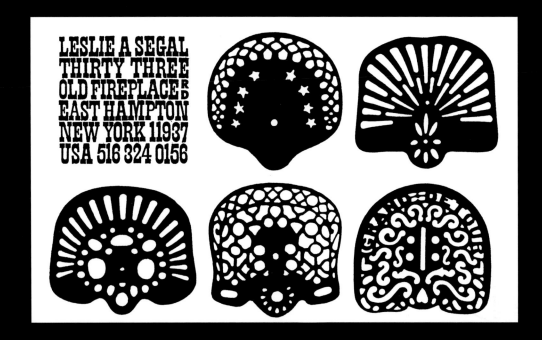

project: **Leslie A. Segal Collector's Business Card**
client: **Leslie A. Segal**

In Leslie Segal's off hours, the
designer is an antique collector and
leaves this card behind with dealers
and rural junkyard owners. Printed
only in one color, the card is memo-
rable for its unusual imagery.

design firm: ANA COUTO DESIGN
creative director: ANA COUTO
designers: ANA COUTO, LUCIANA PINTO
printer: ART3 IMPRESSOS ESPECIAIS
paper stock: 8 ALTA ALVURA SHEETS OF
PAPER PASTED ON BOTH SIDES OF 8
PARANÁ SHEETS OF PAPER CONNECTED
WITH PLASTIC STRIPS
printing: 4 OVER 4, OFFSET
dimensions: CLOSED—
6 3/4" x 6 3/4"
(17 CM X 17 CM)

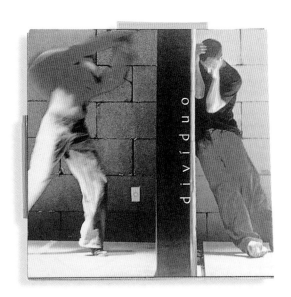

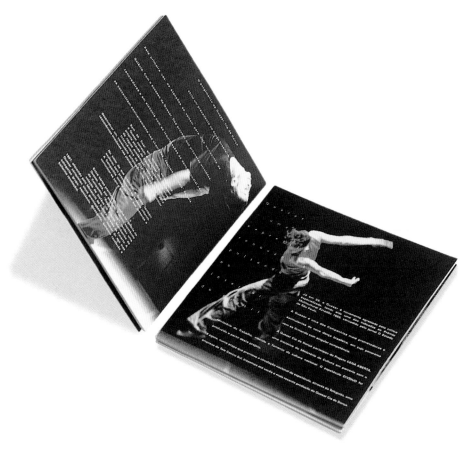

project: **QUASAR COMPANHIA DE DANÇA BROCHURE**
client: **QUASAR CIA. DE DANÇA**

The unique construction, motion photography, and symbolism inherent in this brochure for a Brazilian dance company make it a keepsake that communicates above the din. The brochure is constructed of four small, square, 1/8"- (.3 cm) thick panels, printed front and back with vivid, interpretative photography of solitary dancers in motion. Panels are interconnected with plastic strips, so while individually, each panel is small in size, when the brochure is opened, the panels combine to make a big impression. According to Ana Couto Design, designers chose this format to illustrate different spaces with no contact in between. The brochure is designed to replicate the layout of the stage, where four different compartments are divided by walls, and lines on the ground where dancers occupy their own space.

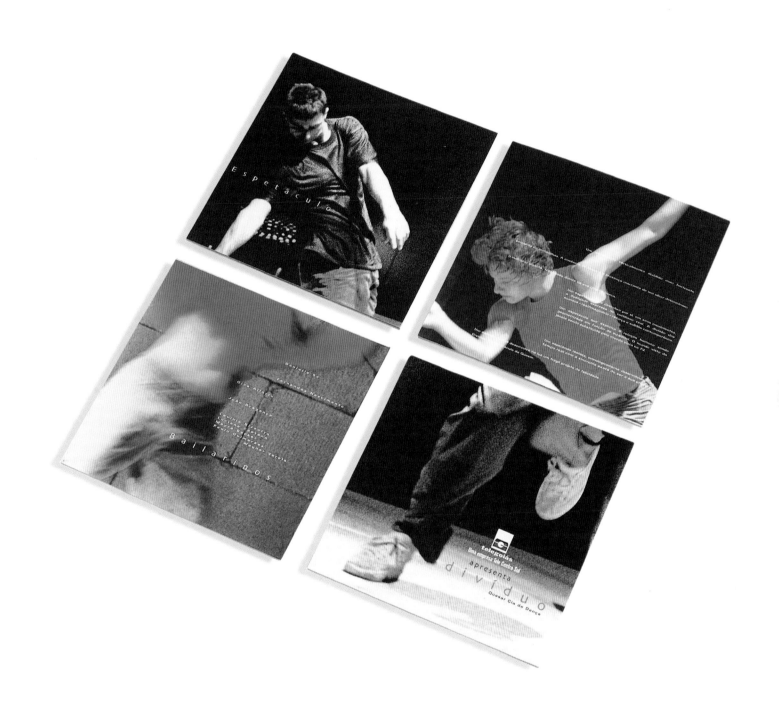

(p 124-127)
design firm: HGV Design Consultants
art directors/designers: Jim Sutherland,
Pierre Vermeir
photographer: Duncan Smith
printer: CTD
paper stock: McNaughton Skye pXm
printing: 4 colors, offset
quantity: 10,000
dimensions: 4 1/8" x 5 3/4"
(10.5 cm x 15 cm)

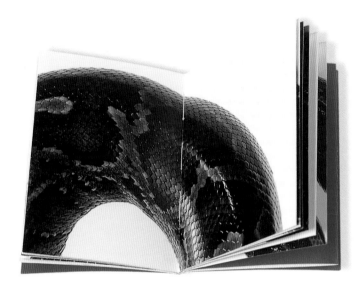

project: "Man, Woman, and Snake" McNaughton Skye pXm
Paper Promotion
client: James McNaughton Paper Group Limited

HGV Design Consultants created this series of three booklets as mailers promoting Skye pXm, a new paper stock. Each is based on the theme of temptation, and the images chosen for each book represent its origins: a man, a woman, and a snake. Photographs of these images are shown as body parts—only a portion of which is revealed on each page. Wondering what isn't revealed only heightens the sense of temptation.

From a practical standpoint, despite the size of the booklets, one doesn't get the sense that the promotion is small. Photos are large to demonstrate print detail, and there is a major fold-out in each book.

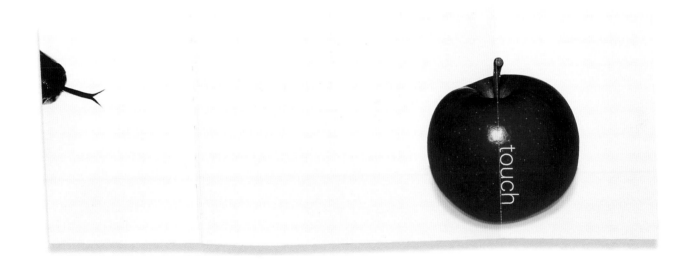

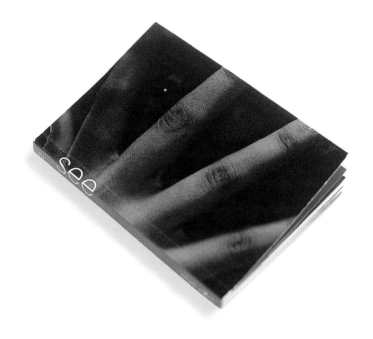

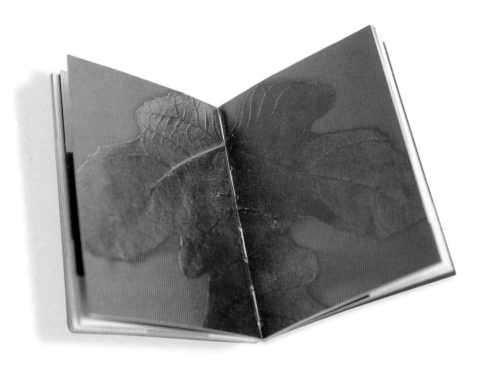

design firm: AERIAL DESIGN
art director: TRACY MOON
designers: TRACY MOON, STEPHANIE WEST
photographer/copywriter: TRACY MOON
printer: LEEWOOD PRESS, INC.
paper stock: STRATHMORE WRITING BRIGHT
WHITE WOVE 80 LB. TEXT
printing: 1 PMS METALLIC (MONOTONE)
INK FOR IMAGERY AND 1 PMS INK FOR
TEXT OVER 2 PMS INKS, OFFSET
quantity: 500 EACH OF 18
dimensions: 3" (8 CM)
CUSTOM OVAL DIE-CUT

project: COLLAGE SALON BUSINESS CARD
client: COLLAGE SALON

Aerial designed these business cards for a high-end salon that specializes in traditional services as well as more modern spa therapies. Designers opted to work in two colors to be cost-effective. They chose a color palette of soft seafoam green metallic and a burgundy accent to create an image that communicates the upscale nature of the salon, as well as it being a peaceful and soothing place to visit. Selecting the two colors was one of the most difficult aspects of the projects, according to designers. Creating a photographic montage that was both appealing and legible at such a small size was also tricky.

(P 129-131)

design firm: PEPE GIMENO—
PROYECTO GRÁFICO
art director: PEPE GIMENO
designer: JOSÉ PASCUAL GIL
illustrators: SEBASTIÁN ALÓS,
PEPE GIMENO

postcards—
photographer: JUAN GARCIA ROSELL
popywriter: PEPE GIMENO
printer: GRÁFICAS VERNETTA, S.A.
paper stock: CREATOR SILK 350 G,
IVERCOTE G. 300 G
printing: 4 COLORS, OFFSET
quantity: 65,000
dimensions: 4 1/2" x 6 1/4"
(11 CM X 16 CM)

catalog—
photographers: VARIOUS
copywriter: MANUELA RABADÁN
printer: PRESVAL
paper stock: CREATOR SILK 300 G,
CREATOR SILK 135 G
printing: 4 COLORS, OFFSET
quantity: 65,000
dimensions: 5 1/2" x 5"
(14 CM X 13 CM)

project: 36TH INTERNATIONAL FURNITURE FAIR OF VALENCIA,
SPAIN, CATALOG AND POSTCARDS
client: FERIA INTERNACIONAL DEL MUEBLE DE VALENCIA

A chair is the trademark visual element that pulls together two promotional pieces for an international furniture fair: a booklet of postcards and a brochure with CD-ROM.

A series of seven postcards is bound into a booklet, entitled *7 Adjectives*, chosen for their succinct description of the Valencia Furniture Fair—pioneering, innovative, fascinating, etc. Each adjective gets its own postcard with the fair's trademark chair rendered in various styles that graphically parallel its adjective. The brochure chronicles the history and future plans of the fair and appears more like an upscale furniture catalog than show guide, with its beautiful product photography. Despite its high-end appearance, at its heart, this brochure is still a show guide, as evidenced by the inclusion of a map of the exhibition floor along with directions to the show.

Feria Internacional del Mueble presenta en su 36 edición el certamen comercial que todos los profesionales del sector estaban esperando: una feria **pionera** en la cultura del diseño de su oferta, **innovadora** por la selección y sectorización de su oferta, **coherente** con su larga trayectoria, **fascinante** como la ciudad que la acoge, **completa** por su amplia superficie de exposición, **rentable** por su volumen de negocio y **competitiva** por sus excelentes comunicaciones, servicios e instalaciones. Estos siete adjetivos perfilan un evento que ha sabido posicionarse como la mayor feria monográfica de España y la sexta del mundo.

For its 36th edition the commercial International Furniture Fair is presenting the commercial event that all the professionals in the sector have been waiting for: a fair that is **pioneering** through the selection in design culture, **innovative** offer, **consistent** with its long-standing tradition, **fascinating** like the city that hosts the event, **complete** thanks to its vast exhibition area, profitable through its excellent communications, services and facilities. These seven adjectives sum up an event that has managed to become the greatest monographic fair in Spain and sixth biggest in the world.

RUSTIC FURNITURE

THE NATURAL WAY. The boom in Rustic Furniture continues, with demands closely linked to new consumer trends. Informal atmospheres, leisure homes and country cottages call for the revival of a style evoking former times and requiring special manufacturing methods to achieve a natural appearance and more rudimentary looks.

Originally, this section comprised craftsmen and artisan workshops, the majority of which, growing as one generation succeeded another, to become companies of longstanding tradition which have enhanced both their national and international scope and adapted themselves to target ongoing expansion of this kind of furniture, apart from careful attention to certain basic rules, the renewal nature does of the product are a major consideration. The products on display are made using traditionally treated woods and materials to achieve a finish of the highest quality and durability.

Rustic furniture occupies an ever-increasing area of 5,000 square metres, where major firms can be found in a section specially noted for its traditional, popular aesthetic and manufacturing a style so deeply rooted in Europe.

design firm: METALLI LINDBERG ADV.
creative director: LIONELLO BOREAN
account manager: STEFANO DAL TIN
paper stock: FEDRIGONI SPLENDORLUX
printing: 5 COLORS PLUS SILVER INK
quantity: 800–1,000
dimensions: 4" x 3" x 8"
(10 CM X 8 CM X 20 CM)

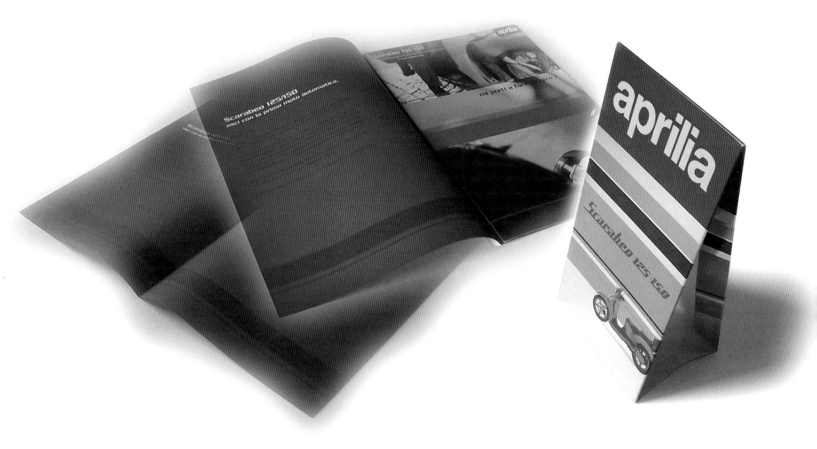

project: **APRILIA PLACE MARKER**
client: **APRILIA S.p.A.**

Aprilia, a manufacturer of motorcycles, used these place markers during a special press luncheon in Lisbon to announce its new Scarabeo 125-150 model. No simple table markers were used for this event. These markers included graphics and colors that were chosen to enhance the shiny chrome details of the scooter and its retro lines—all totaled, a lot of information to include in a table tent.

design Firm: ERWIN ZINGER GRAPHIC DESIGN
art director/designer: ERWIN ZINGER
photographer: JOHN WELLING
printer: PLANTIJN CASPARIE
paper stock: PERGAMIJN 50 G/M2,
CONFETTI KALEIDOSCOPE 120 G/M2
printing: 3 COLORS, OFFSET, HIGH-GLOSS FOIL
quantity: 500
dimensions: **6 1/4" x 6 1/4"
(16 CM X 16 CM)**

project: **GOVERNMENT OF NOORDENVELD RETIREMENT INVITATION**
client: **GOVERNMENT OF RODEN**

Designer Erwin Zinger created this invitation to commemorate the retirement of a key individual with the Noordenveld government. Because the employee was so central to every facet of the organization during his tenure, Zinger juxtaposed a photo of the man waving goodbye with a photo of a hand waving a handkerchief as if in reply. He laid these two photos against a spider's web—rendered as a texture on the Pergamijn translucent cover paper.

THE MAN WHO REMOVES A MOUNTAIN
BEGINS BY CARRYING AWAY SMALL STONES.

—anonymous

Specialty graphics can't be labeled. They don't fit any preconceived idea of what constitutes a small graphic. Yes, they are small, but they are also atypical. They excel in their uniqueness. They are classified as specialty graphics because of an unusual application, substrate or production technique.

Some are engraved; some use holograms or intriguing die-cuts to communicate. Here, you'll find inspiration for designing in small spaces on premiums and giveaways, including hats, buttons, matchbooks, and even squeezeable flashlights. Because no item is ever considered too small for great design, creating powerful images for everything from hang tags

and sugar packets to miniature airline salt and pepper shakers, are reviewed. Also included is a collection of what some would consider the definitive small graphic—the humble postage stamp. However, in this case, they aren't so humble, as you'll see after more than twenty-six San Francisco–area designers took on the challenge of designing a 1 1/4" x 2" (3.5 cm x 5 cm) postage stamp for the San Francisco chapter of the American Institute of Graphic Arts. Their efforts, like those from the other designers represented in this chapter, demonstrate how truly powerful small-scale graphics can be.

The imagery is diverse, but they all have two things in common: They are diminutive and they reinforce the adage that good things do indeed come in small packages.

design firm: SAGMEISTER INC.
art director: STEFAN SAGMEISTER
designers: STEFAN SAGMEISTER, HJALTI KARLSSON
photographer: MAX VADUKUL
illustrators: KEVIN MURPHY, GERARD HOWLAND
(FLOATING COMPANY), ALAN AYERS
paper stock: MATTE VARNISHED GLOSS
80 LB. TEXT
printing: 6 COLORS
quantity: 1,000,000
dimensions: 4 3/4" x 4 3/4"
(12 CM X 12 CM)

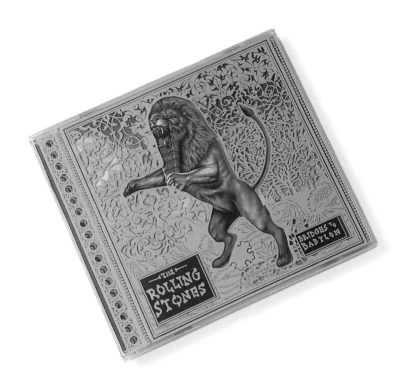

project: **THE ROLLING STONES *BRIDGES TO BABYLON* CD**
client: **PROMOTONE B.V.**

The illustration of an Assyrian lion on this CD jacket is so distinctive, it alone makes The Rolling Stones *Bridges to Babylon* CD a standout. But Sagmeister Inc. doesn't leave this image alone to sell the CD from the shelf. The plastic jewel case slides into a specially manufactured filigree slipcase that gives the appearance of three dimensions as if the lion were embedded into the design.

design firm: SAGMEISTER INC.
art director: STEFAN SAGMEISTER
designers: STEFAN SAGMEISTER,
VERONICA OH
photographer: TOM SCHIERLITZ
printer: NIMBUS
paper stock: GLOSS 80 LB. TEXT
printing: 1 COLOR
quantity: 10,000
dimensions: BOOKLET—
3 1/4" x 3 1/2"
(8.5 CM X 9 CM)
CD—4 3/4" x 4 3/4"
(12 CM X 12 CM)

project: MARSHALL CRENSHAW *MIRACLE OF SCIENCE* CD
client: RAZOR & TIE

Playing to the CD's name, *Miracle of Science*, Sagmeister Inc. decided to design the packaging with an optical illusion built in. The CD itself features a hologram that is visible on store shelves through the packaging. The jewel-case jacket, listing the musical tracks, was reduced in size so that the CD would always be visible behind it. The insert features multiple gatefolds and one-color graphics that echo the hologram design.

design firm: CHEN DESIGN ASSOCIATES
art director: JOSHUA C. CHEN
designer/illustrator: LEON YU
photographers: TERRENCE MCCARTHY
(MTT COVER PHOTO),
JOSHUA ROBISON (MTT W/ COPLAND)
printer: OSCAR PRINTING (SLEEVE),
KABA AUDIO (CD)
paper stock: POTLATCH MCCOY SILK
printing: 2 COLORS, SHEETFED
quantity: 2,200
dimensions: 5 1/2" x 4 7/8"
(14 CM X 12 CM)

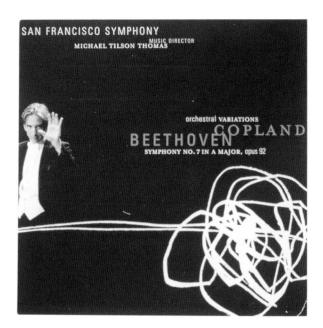

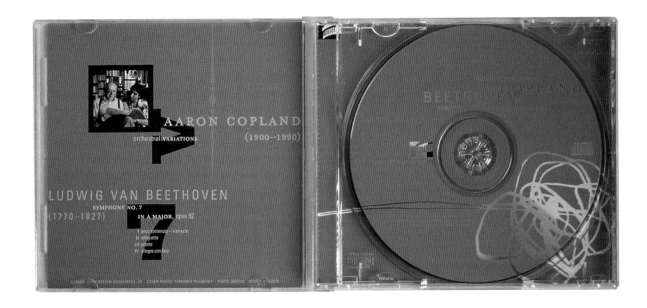

project: COPLAND/BEETHOVEN SPECIAL EDITION CD
client: SAN FRANCISCO SYMPHONY

The San Francisco Symphony's Grammy Award winning Music Director Michael Tilson Thomas, renowned for his distinctive and bold programming of classical music, paired the work of two great mavericks in this live recording. The two pieces are, as Thomas states in the jacket, "reflections of the Dionysian improvisatory frenzy of their creators." Designer Leon Yu's interpretation of these themes produced a jacket that balanced a refined elegance with symbols of the creative frenzy that is so often its wellspring.

design firm: CHEN DESIGN ASSOCIATES
art director: JOSHUA C. CHEN
designers: JOSHUA C. CHEN,
KATHRYN HOFFMAN
printer: MADISON STREET PRESS
paper stock: LITHOFECT 80 LB. DULL COVER
printing: 4 COLOR PROCESS PLUS VARNISH,
SHEETFED
quantity: 2,000
dimensions: **4" x 6 1/2"**
(10 CM x 17 CM)

project: **THE PS FILES INVITATION**
client: **ADOBE SYSTEMS, INC.**

This "top-secret" invitation to Adobe Systems Inc.'s media briefing of Postscript Level III included a private investigator's passport/decoder that presented "briefing details" pertinent to the reception event. The invitation presented the information with style and humor, as a tongue-in-cheek take-off of the TV series "X-Files."

design firm: JIM MOON DESIGNS
art director/logo design: JIM MOON
illustrator: TOM HENNESSY
printer: DICKSON'S, INC.
paper stock: B60 SIMPSON ESTATE EIGHT
LABEL UNCOATED, WHITE
printing: 4-COLOR PROCESS AND MATTE
VARNISH, SHEETFED, EMBOSSED,
ENGRAVED, AND FOIL STAMPED
quantity: 124,000
dimensions: FRONT LABEL—
2 1/2" x 4"
(6 CM X 10 CM)
BACK LABEL—3" X 4"
(8 CM X 10 CM)

project: BECKMEN WINE LABEL AND BIRTH ANNOUNCEMENT
client: BECKMEN VINEYARDS

Jim Moon updated Beckmen Vineyards's label with this distinctive design that incorporates not just four-color process, but embossing, foil stamping, and engraving—all in a 2 1/2" x 4" (6 cm x 10 cm) space. Dickson's, Inc., an Atlanta specialty printer, suggested engraving the intricate oak tree illustration for maximum effect. "The sum of its specialty processes and the simplicity of the design set it off from a crowded field," said Moon.

With the birth of a new Beckmen at the winery, Dickson's surprised the winemaker by printing a variation on the wine label as a birth announcement. To make use of the labels and commemorate the occasion, Beckmen bottled a special run of sparkling wine.

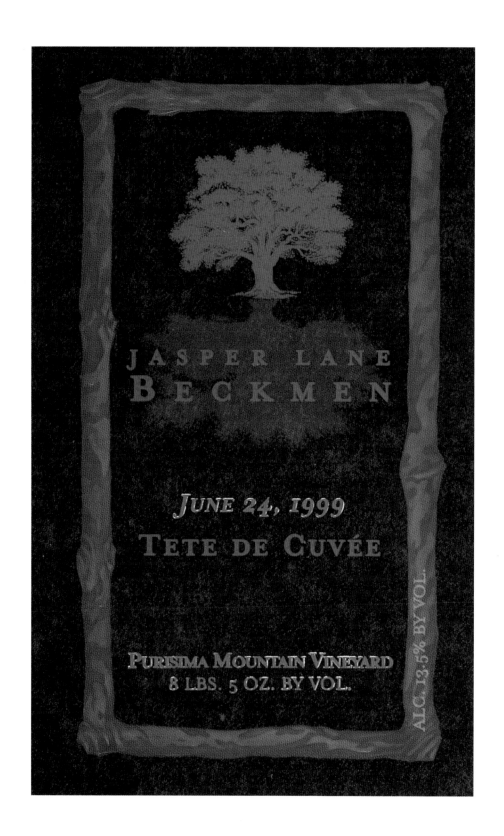

design firm: JIM MOON DESIGNS
art director: JIM MOON
illustrator: ADAM SCHNITZER
printer: SPECTRUM GRAPHICS
paper stock: B60 SIMPSON ESTATE EIGHT
WHITE UNCOATED LABEL
printing: 4-COLOR PROCESS, MATTE
VARNISH, DIE-CUT, SHEETFED
quantity: 1,500
dimensions: 3 1/4" x 4"
(8 CM x 10 CM)

project: MUSTARDS GRILL SINGLE BARREL WINE LABEL SERIES,
RED SHOULDER CABERNET FRANC
client: BENTON-LANE WINERY

Napa Valley's Mustards Grill annually invites a local vintner to produce a special barrel of wine that reflects its style of winemaking. The wine is then sold in the restaurant with all proceeds given to the Napa Valley Opera House Restoration Fund. The artwork commissioned for the wine labeling is auctioned and donated, too. Because this event regularly attracts so much attention, the wine label has become almost as important as the vintage itself. This year, the client wanted a look that would be humorous. In a dramatic departure from traditional European styling that is known for its conservative type-only approach, Jim Moon created a label that is die-cut to look like a red cotton T-shirt, effectively distancing this vintage from any others.

RED SHOULDER
1994 CABERNET FRANC
NAPA VALLEY TABLE WINE
MUSTARDS GRILL
SINGLE BARREL SERIES

This Cabernet Franc fruit came from Shafer
Vineyards' renowned Red Shoulder Ranch in
Carneros. Picked at 24.5 Brix and 100% barrel
fermented (Tarnsaud-Allier Wood - Heavy
Toast). The wine was bottled unfiltered and
unfined. A donation to the Napa Valley
Opera House Restoration Fund will be made
for each bottle sold. Our sincere appreciation
and thanks to Proprietors John and Doug
Shafer, Winemaker Elias Fernandez and
Artist Adam Schnitzer.

·Michael Ouellette·

PRODUCED & BOTTLED BY SHAFER
VINEYARDS, NAPA, CALIFORNIA

GOVERNMENT WARNING: (1) ACCORDING TO THE SURGEON GENERAL,
WOMEN SHOULD NOT DRINK ALCOHOLIC BEVERAGES DURING PREGNANCY
BECAUSE OF THE RISK OF BIRTH DEFECTS. (2) CONSUMPTION OF ALCOHOLIC
BEVERAGES IMPAIRS YOUR ABILITY TO DRIVE A CAR OR OPERATE MACHINERY,
AND MAY CAUSE HEALTH PROBLEMS

750 ML / **CONTAINS SULFITES**

design firm: FABRICE PRAEGER
art director/designer/copywriter:
FABRICE PRAEGER
printing: 4-COLOR PROCESS, OFFSET
quantity: 3,000 EACH OF APPROXIMATELY 76
dimensions: 1 1/2" x 1"
(4 CM X 3 CM)

project: FABRICE PRAEGER'S LITTLE PICTURES
client: FABRICE PRAEGER

Designer Fabrice Praeger is known around Paris for the little pictures he gives away to people on the street and at exhibitions. Often, he carries a selection of the more than seventy images in a small box he wears on his jacket. These are images he creates from concepts of his views about sex, money, and love. Twice a year, he turns them into miniature billboards by fitting them into the edges of his regular print jobs. Some images hit on more weighty subjects, ranging from topics as diverse as nuclear testing to blood-pressure testing.

The images have caused quite a stir, generating considerable media attention, requests for exhibitions, and proposals from retailers who want to sell the images in their shops.

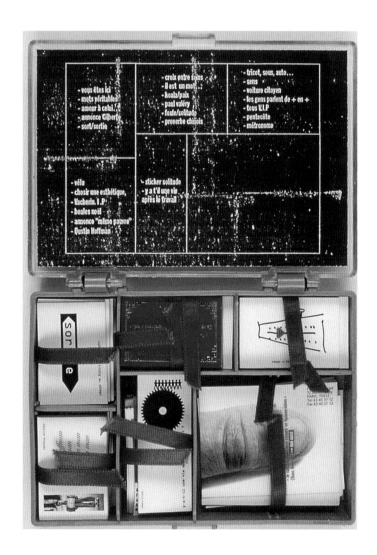

design firm: JIM MOON DESIGNS
art director: JIM MOON
logo design: JIM MOON, TOM HENNESSY
illustrator: TOM HENNESSY
printer: DPI/HEMLOCK ALLIANCE
paper stock: B100 VINTAGE GLOSS COVER
printing: 4-COLOR PROCESS PLUS 9 PMS INKS
(INCLUDING 2 DOUBLE-HITS) AND AQUEOUS
COATING OVER 4-COLOR PROCESS AND 2 PMS
INKS, SHEETFED
quantity: 100,000
dimensions: 2" x 3 5/8"
(5 CM X 9.5 CM)

logo design: JIM MOON, TOM HENNESSY
illustrator: TOM HENNESSY

TOMATINA
1016 MAIN STREET
ST. HELENA, CA 94574
707/967-9999

1325 NO. MAIN STREET
WALNUT CREEK, CA 94596
925/930-9999

3127 MISSION COLLEGE BLVD.
SANTA CLARA, CA 95054
408/654-9000

FALL 1998
STRAWBERRY VILLAGE
MILL VALLEY, CA 94941

LOONGBAR
GHIRARDELLI SQUARE
AT BEACH & POLK STREETS
SAN FRANCISCO, CA 94109
415/771-6800

POSTINO
3565 MT. DIABLO BLVD.
LAFAYETTE, CA 94549
925/299-8700

BISTECCA
FALL 1998
FASHION SQUARE
7014 E. CAMELBACK ROAD
SCOTTSDALE, AZ 85251
602/481-7800

244 JACKSON STREET
SAN FRANCISCO, CA 94111

project: REAL RESTAURANTS PROMOTIONAL CARD SET
client: REAL RESTAURANTS OWNER

Real Restaurants, a collection of fine and diverse eateries in California, presents the unique personality and atmosphere of each of its restaurants on a business card, all of which are featured in a custom display in each venue—almost as though they were collectible art. "We wanted high-quality printing to establish a level of quality one can anticipate before visiting the restaurant," said Jim Moon. The entire job was gang-run for production efficiency.

client: **Mustards Grill,**
Real Restaurants Owner
logo design: **Jim Moon**
copywriters: **Jim Moon,**
Michael Ouellette, BSPC Higgins

client: **Fog City Diner,**
Real Restaurants Owner
logo design: **Rod Dyer**
copywriter: **BSPC Higgins**

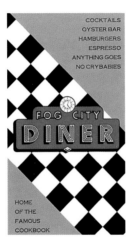

client: **Tra Vigne,**
Real Restaurants Owner
logo design: **Michael Mabry**
copywriters: **BSPC Higgins,**
Kevin Kronin (Tra Vigne)

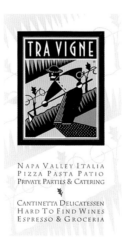

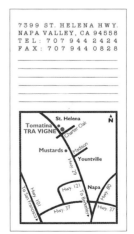

client: **Bix, Real Restaurants Owner**
logo design: **Rod Dyer**
copywriter: **Doug Biderbeck**

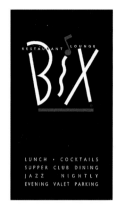

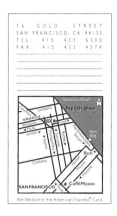

client: **Caffe Museo,**
Real Restaurants Owner
logo design: **Katherine Mills**
copywriters: **BSPC Higgins, Jim Moon**

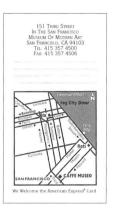

client: **Tomatina,**
Real Restaurants Owner
logo design: **Michael Mabry**
copywriters: **BSPC Higgins, Jim Moon**

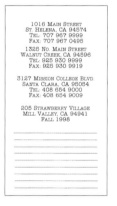

client: **Betelnut,**
Real Restaurants Owner
logo design: **Russell Leong**
copywriters: **BSPC Higgins, Jim Moon**

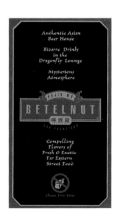

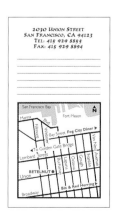

client: **Loongbar,**
Real Restaurants Owner
logo design/illustrator: **Jennifer Morla**
copywriters: **Bill Higgins, Jim Moon**

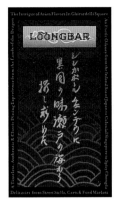

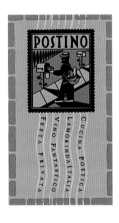

client: **Postino,**
Real Restaurants Owner
logo design: **Michael Mabry**
copywriters: **Jim Moon, Bill Higgins**

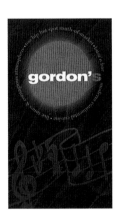

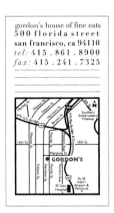

client: **Gordon's House of Fine Eats,**
Real Restaurants Owner
logo design: **Katherine Mills**
copywriters: **Jim Moon,**
Gordon Drysdale

client: **Real Restaurants Owner**
illustrator: **Thomas Hennessy**
copywriters: **Jim Moon, Bill Higgins**

This card was designed to promote employment opportunities and was included with the rest of the business cards to catch the attention of prospective managers. Notice the minute version of the Real Restaurants logo on the chef's shirt.

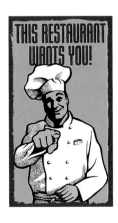

design firm: MIRES DESIGN, INC.
art directors: JOHN BALL,
JOSÉ A. SERRANO
designer: GRETCHEN LEARY
photographer: HARRY CHAMBERLALIN
copywriter: BRIAN WOOLSEY
printing: 4 COLORS, OFFSET
dimensions: 3" (8 CM) DIAMETER

project: **FRESCANTE "ICE" BUTTONS**
client: **BOYDS COFFEE**

Mires Design, Inc. admits that it wasn't easy fitting a photo and a headline on so small a button, but designers did just that to introduce a new coffee beverage. Nothing beats an iced drink on a hot day, and knowing that this drink is the Italian version of a coffee-flavored milkshake has appeal for a large segment of the population. Mires Design used this knowledge to create a fun promotion that features the product, in Mires' words, "as a delicious, yummy, feel-good drink."

design firm: **Lima Design**
art director: **C. Butter**
designers: **Lisa McKenna, Mary Kiene**
printer: **Shawmut Printing**
paper stock: **Monadnock Caress 80 lb. cover**
printing: **2 colors, offset**
dimensions: **3 3/8" x 4 3/4"
(8.5 cm x 12 cm)**

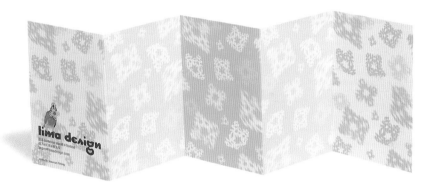

project: **Lima Design Holiday Card**
client: **Lima Design**

Lima Design's corporate color complements this holiday card that continues the firm's tradition of eclectic holiday greetings. All the traditional holiday symbols, including Rudolph's nose and Santa's hat, are spot colored in "Lima" green.

Interestingly, the reverse of the accordion-folded card is not ignored. It is also dressed for the holidays with a visually compelling snowflake pattern that appears 3-D.

design firm: LIMA DESIGN
designers: LISA MCKENNA, MARY KIENE
printer: SHAWMUT PRINTING
paper stock: MACTAC STARLINER
printing: 4-COLOR PROCESS, OFFSET
dimensions: DISK LABEL—
2 3/8" x 2 1/8"
(6 CM X 5 CM),
RECTANGULAR LABEL—
2 1/2" x 13/16"
(6 CM X 2 CM),
SQUARE LABEL—
1 1/4" x 1 1/4"
(3 CM X 3 CM)

project: LIMA DESIGN LABEL SYSTEM
client: LIMA DESIGN

Lima Design has created labels for all of its administrative needs from labeling diskettes to dressing up envelopes and whatever else may benefit from an added reminder of the firm's capabilities. The imagery varies from label to label; all are intriguing and all are effective because they communicate and are practical, too.

design firm: STUDIO GT & P
art director: GIANLUIGI TOBANELLI
printer: MORGAN S.P.A.
printing: 7 COLORS, GRAVURE
dimensions: 2" X 2 3/4"
(5 CM X 7 CM)

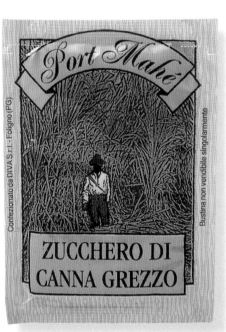

project: PORT MAHÉ CANE SUGAR PACKAGING
client: DIVA INTERNATIONAL S.R.L.

These richly graphic sugar packets would never be confused with the ordinary blue, pink, and white packets, which have all but replaced those that used to be customized for individual hotels and restaurants with intriguing graphics of their own. Port Mahé cane sugar stands out, not only because it is evident that it is printed in seven colors, but those colors are the perfect foil for the stylized illustration of a cutter standing amid the sugar cane.

design firm: STUDIO GT & P
art director: GIANLUIGI TOBANELLI
printer: TIPOGRAFIA NATI
printing: 4 COLORS, OFFSET
dimensions: 3 1/2" x 5 1/2"
(8.5 CM X 14 CM)

project: ADAMANTIS ITALIAN GRAPPA LABEL
client: PENTA STAR S.R.L.

The distinctive *A*, signifiying the Adamantis Grappa brand, is printed in silver metallic ink, as is the product name, on this elegant label. This design is evidence that sometimes a specialty treatment can be so effective that illustration, photography, and even copy, can be omitted—particularly when a design needs to communicate a lot in a small space.

design firm: Studio GT & P
designer: Gianluigi Tobanelli
quantity: 800,000
dimensions: 2 1/2" x 1" x 1"
(6 cm x 3 cm x 3 cm)

project: Diva International Salt & Pepper Shakers
client: Diva International S.r.L.

These miniature salt and pepper
shakers, designed for an Italian
airline company, fit snugly into
silver-tone, blue, or cranberry red
trays to ensure they stay put, even
during turbulence. They are topped
off with color-coordinating caps in a
design that is both functional and
visually appealing.

design firm: MIRES DESIGN, INC.
art director: JOHN BALL
designers: JOHN BALL, DEBORAH HORN,
MIGUEL PEREZ

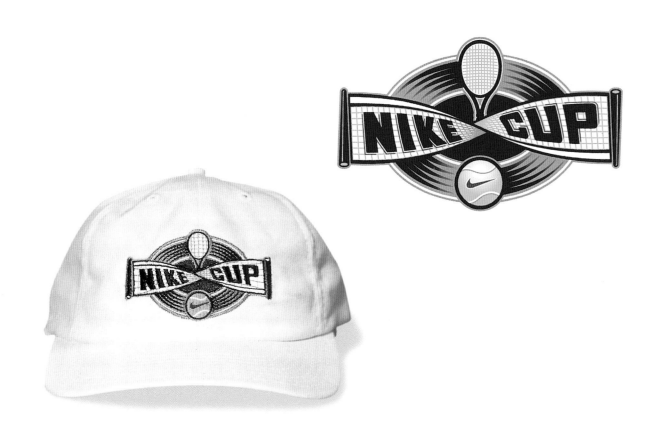

project: NIKE CUP HAT
client: NIKE INC.

The Nike Cup is part tennis tourna-
ment, part entertainment, and show-
manship—with its own rules and a
comic emcee. Since it is billed as
"tennis with a twist," the natural
choice for the primary logo graphic
was a twisted net. Embroidery threads
in vivid colors give life and texture to
the logo on the white cap, but it also
posed the biggest design challenge.
Designers had to create a simplified
version of the logo to maintain its
integrity despite the limited detail
possible with the embroidery process.

design firm: **Büro für Gestaltung**
designers: **Christoph Burqardt,**
Albrecht Hotz
imaging: **3 colors, silk screen**
quantity: **1,500**
dimensions: **4 1/8" x 8 1/4"**
(10 cm x 21 cm)

project: **Künstlerhaus Mousonturm Invitation**
client: **Mousonturm**

To commemorate the opening of a new season, the Mousonturm, an independent theater house that organizes ballets, concerts, and other performances, commissioned artist Hagen Bonifer to create a three-dimensional work that people would walk through to experience. The result was an enlarged entrance to the theater composed of glass stones that were lit from behind to create shades of blue and blue-green. Designers replicated this design on the invitation to the theater's opening, silk-screening a small piece of clear plastic with two shades of blue and blue-green.

design firm: ORANGE
art director/designer: SUSAN LEE
printer: LEAHON PRINTING
printing: 2 COLORS, SHEETFED
quantity: 20,000
dimensions: SHIRT TAGS—
2 3/4" x 2 3/4"
(7 CM x 7 CM);
PANT TAG—5 1/4" x 7"
(13 CM x 18 CM)

project: **FLOSPORT/SLANT-6 CLOTHING TAG SYSTEM**
client: **FLOSPORT/SLANT-6 CLOTHING**

In keeping with the contemporary
design of the Flosport/Slant-6 cloth-
ing line and its youthful appeal
(women ages fifteen to twenty-two),
the tag system is techy, yet fun. Both
qualities are rendered graphically
through its dynamic icon and in its
use of a silver and high-energy orange
color palette.

design firm: SAYLES GRAPHIC DESIGN
art director/designer/illustrator:
JOHN SAYLES
paper stock: NEENAH CLASSIC CREST
NATURAL WHITE 110 LB.
printing: 2 COLORS, OFFSET
quantity: 250
dimensions: 3 1/2" x 2"
(9 CM X 5 CM)

project: BIG DADDY PHOTOGRAPHY BUSINESS CARD
client: BIG DADDY PHOTOGRAPHY

When Roger Kennedy asked Sayles Graphic Design to create an identity for his studio, Big Daddy Photography, John Sayles went to work creating a visual that he says was inspired by the studio's name. He began by illustrating a grinning Daddy character and hand-rendering the type that reminds clients to "Say Cheese!" He compiled this image into the shape of a camera. Finally, he finished off the card with specialty die-cutting.

design firm: BELYEA
art director: PATRICIA BELYEA
designer: RON LARS HANSEN
copywriter: DALE LEMAN
printer: WINWARD PRESS
paper stock: COUGAR OPAQUE 70 LB.
printing: 4-COLOR PROCESS OVER BLACK,
SHEETFED
quantity: 20,000
dimensions: 2 1/4" x 2 1/4"
(5.5 CM x 5.5 CM)

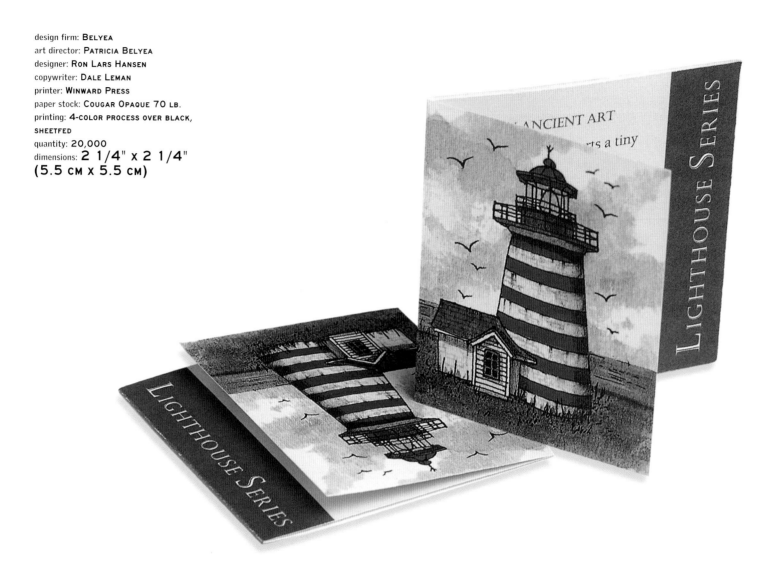

project: **GLASS EYE LIGHTHOUSE GIFT TAGS**
client: **GLASS EYE STUDIO**

The graphic on Glass Eye Studio's Lighthouse gift tags is taken from an original watercolor design painted by Bev Schreiber, whose paintings are also replicated on a series of hand-painted lighthouse ornaments. Copy tells the story of the art and technique of the piece, and provides insight to the history of lighthouses. Despite its miniature size, this gift tag packs a tremendous amount of information, and, when coupled with the lighthouse graphic, makes for a keepsake to be saved and treasured along with the ornament.

design firm: AFTER HOURS CREATIVE
printer: HERITAGE GRAPHICS &
LASERCRAFT
printing: 1 COLOR, OFFSET
quantity: 5,000
dimensions: 3 1/2" x 2"
(9 CM X 5 CM)

project: CLEARDATA.NET BUSINESS CARD
client: CLEARDATA.NET

ClearData.Net's company name is
translated in quite literal terms on its
business card, where the word "clear"
is literally clear. Using laser die-cutting
was the only way to precisely die-cut
the letterforms that form the word
"clear" to such exact specifications.

design firm: Aerial Design
art director/designer/copywriter: Tracy Moon
photographer: R. J. Muna
(R. J. Muna Pictures)
paper stock: White card stock
printing: 2 PMS duotone for imagery,
PMS for text, and flood gloss
laminate, offset
quantity: 10,000
dimensions: 2" x 2" (5 cm x 5 cm)

project: **Lenox Room Restaurant Matchbook**
client: **Lenox Room**

Uniquely designed matchbooks that reflect a restaurant's tone and atmosphere seem to have become a thing of the past. They have been replaced by generic, one-design-fits-all versions, or have disappeared entirely, especially in establishments where nonsmoking areas dominate. New York's Lenox Room restaurant has recaptured this lost art. Its matchbook complements its corporate identity and works as both a matchbook and a miniature business card. For designers, their biggest challenge was to translate the imagery of the identity system to a small, folded matchbook cover. "Additionally, the vendor who printed the books was not a high-end printer, so we were not given matchprints or press checks for quality control," says Tracy Moon, art director. "We tried to make the design foolproof by using larger type and simple, clean graphic files to ensure that the color and imagery would reproduce properly."

design firm: AERIAL DESIGN
art director: TRACY MOON
designers: TRACY MOON, STEPHANIE WEST,
KIMBERLY CROSS
copywriter: TRACY MOON
printer: LEEWOOD PRESS, INC.
paper stock: WHITE CARD STOCK
printing: 2 COLOR DUOTONE, OFFSET
quantity: 5,000
dimensions: 2 1/4" x 3 3/8"
(5.5 CM X 8 CM)

project: TRIBE PICTURES "LUMALITE" PROMOTIONAL ITEM
client: TRIBE PICTURES

Tribe Pictures, makers of feature and corporate films, wanted a cost-effective, yet eye-catching design for a small, handheld, squeezable flashlight to promote a new feature-film director and communicate the company's name and Web site. To maintain costs, designers limited the layout to two colors. Previously, the company identity, which uses soft colors and equally soft imagery, had been applied primarily to larger items, such as film trailers and letterhead. "Adapting the basic feeling of the identity onto such a small piece required careful layout and technical considerations in order to retain the integrity of the identity," says Tracy Moon, art director.

(PAGES 166-169)
design firm: CHEN DESIGN ASSOCIATES
art director: JOSHUA C. CHEN
designers: JOSHUA C. CHEN,
KATHRYN HOFFMAN, LEON YU,
GARY E. BLUM
illustrators: GARY E. BLUM,
ELIZABETH BALDWIN
photographers: JOSHUA C. CHEN, LEON YU
copywriters: JOSHUA C. CHEN,
KATHRYN HOFFMAN
printer: MADISON STREET PRESS
diecutting: CROWN LETTERPRESS
paper stock: GILBERT VOICE SLATE
100 L B. COVER; GLAMA NATURAL CLEAR
53 L B.; FRENCH BUTCHER OFF-WHITE
80 L B.; FRENCH CHIPBOARD 145 L B.
printing: 4-COLOR PROCESS PLUS
1 METALLIC OVER BLACK, SHEETFED
quantity: 1,000
dimensions: **5.5" X 8.125"
(14 CM X 20 CM)**

project: **METH·OD·OL·O·GY 1999 CALENDAR**
client: **CHEN DESIGN ASSOCIATES**

Chen Design Associates commemorated the 12 months of 1999 with a desk calendar in tribute to 12 elements of good design. Although this list of elements ran the gamut from the ethereal to the the technical, the design of each card upheld all 12 while featuring just one.

The calendars themselves were painstakingly hand-assembled. Bound by a metal clip and alternately sealed and propped up by an elastic band, each calendar was hand-stamped with an individual serial number, in keeping with a design meant to evoke the sparse, objective style of the scientific method. The calendars were sent as thank-you gifts to existing clients, and as promotional pieces to potential new clients.

paper stock: FRENCH BUTCHER
OFF-WHITE 80 L B. TEXT
printing: 4-COLOR PROCESS PLUS
1 METALLIC, SHEETFED
quantity: 1000 EACH
dimensions: 4 3/8" x 6 1/4"
(10 CM X 15 CM)

Continuing their tradition of thanking clients with pieces that are both strongly promotional *and* useful for more than mere decoration, designers at Chen Design Associates re-fit their calendar artwork to a series of blank notecards. The series of 12 cards were packaged with mailing envelopes and bound with a ribbon in thanks to clients who could, in turn, use them to thank people who might appreciate the elements of good design—or simply to people who might appreciate tokens of gratitude that couldn't be found in any gift shop.

JANUARY— RELEVANCE
designer/illustrator: GARY E. BLUM

FEBRUARY— STRUCTURE
designer/illustrator: KATHRYN A. HOFFMAN

MARCH— TYPOGRAPHY
designer/illustrator: JOSHUA C. CHEN

 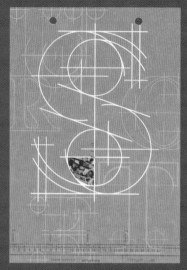

APRIL— BALANCE
designer: LEON L. YU

MAY— CONTRAST
designer: JOSHUA C. CHEN
illustrator: ELIZABETH S. BALDWIN

JUNE— COLOR
designer/illustrator: GARY E. BLUM

JULY— SPACE
designer: LEON L. YU

AUGUST— MOVEMENT
designer/photographer: JOSHUA C. CHEN

SEPTEMBER— HARMONY
designer: KATHRYN A. HOFFMAN

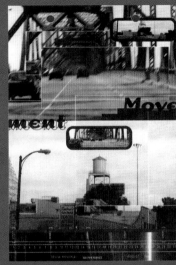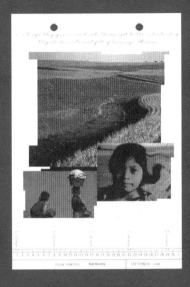

OCTOBER— RHYTHM
designer/photographer: LEON L. YU

NOVEMBER— SPONTANEITY
designer/photographer: LEON L. YU

DECEMBER— CRAFT
designer/illustrator: JOSHUA C. CHEN

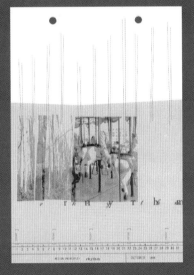

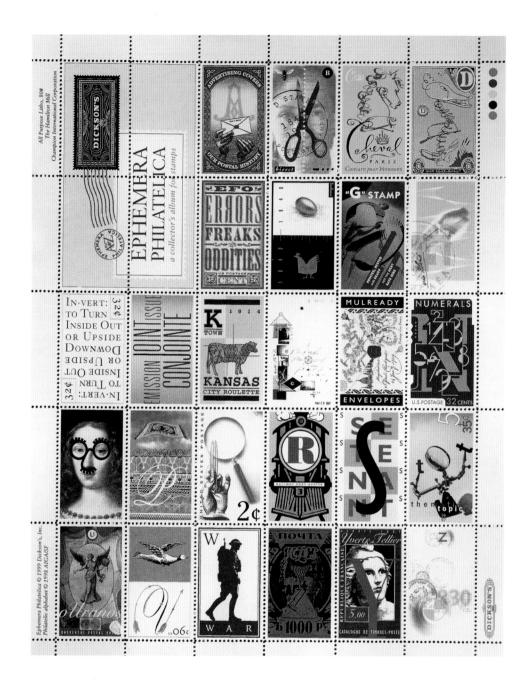

(P 170-173)
printer: DICKSON'S, INC.
stamp sheet: LITHOGRAPHED 4-COLOR PROCESS, 1 PMS INK, AND PERFORATED, ROUND HOLE ON CHAMPION ALL-PURPOSE LITHO, 80 LB. TEXT
dimensions: SHEET OF ALPHABET STAMPS—8 1/2" x 11" (22 CM x 28 CM)
INDIVIDUAL ALPHABET STAMPS— 1 1/4" x 2" (3 CM x 5 CM)

project: **AMERICAN INSTITUTE OF GRAPHIC ARTS, SAN FRANCISCO CHAPTER (AIGA/SF) PHILATELIC ALPHABET (COLLECTIVE WORK) AS REPRODUCED IN** *DICKSON'S EPHEMERA PHILATELICA*
client: **DICKSON'S INC.**

In 1997, "the AIGA/SF board approved developing an event to educate designers about philately in general, and to encourage our colleagues to attend Pacific 97 in particular," says Alyson Kuhn, communications director, AIGA/SF. Bill Senkus, Alyson Kuhn, and Sheryn Labate developed a philatelic alphabet where each letter symbolizes something having to do with the collecting of stamps or sending of mail. The team chose the twenty-six philatelic associations on the basis of three

criteria: educational or anecdotal interest, visual or graphic potential, and personal preference.
"To involve the design community, I asked designers at twenty-six San Francisco Bay Area studios to design stamp images, each for a given letter," remembers Kuhn. The resulting philatelic alphabet made its debut in a presentation by Bill Senkus at the California College of Arts & Crafts in San Francisco. Since then, it has appeared in other presentations, to much acclaim in the design

community, and was showcased during the U.S. Postal Service's third annual conference on stamp design in June 1998. More recently, AIGA/SF licensed the use of the images to Dickson's, Inc., an Altanta-based specialty printer, for use in a self-promotion, demonstrating the firm's multiprocess printing capabilities. *Dickson's Ephemera Philatelica*, is also showcased on pages 174–175. Senkus' evocative definitions of each philatelic term have been abbreviated on the following pages.

A is for ADVERTISING COVERS—
THE JUNK MAIL OF A CENTURY AGO.
designed by MELINDA MANISCALCO,
US WEB CKS

B is for BISECT—A STAMP THAT CAN
BE EASILY CUT IN HALF TO PAY HALF ITS
FACE VALUE.
designed by DOUG AKAGI, ALISON McKEE,
JOANNA WIRAATMADJA, CHRISTOPHER
SIMMONS, AND JASON OSHIRO; AKAGI
REMINGTON

C is for CINDERELLA STAMP—USE THIS
AS A DECORATIVE STAMP. IT DOESN'T HAVE
A FACE VALUE AND CAN'T BE USED FOR
OFFICIAL POSTAGE.
designed by MARTHA NEWTON FURMAN
DESIGN & ILLUSTRATION

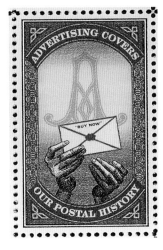
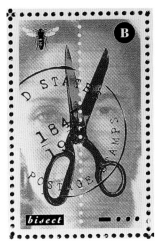
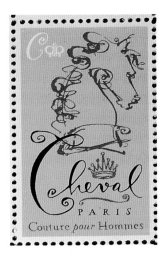

D is for DUCK STAMPS—ISSUED ANNUALLY
BY THE U. S. FISH AND WILDLIFE SERVICE
TO VALIDATE DUCK HUNTING LICENSES.
designed by WARD SCHUMAKER, SCHUMAKER

E is for EFOs—SHORTHAND FOR ERRORS,
FREAKS, AND ODDITIES, OTHERWISE KNOWN
AS MISPRINTS, MISPERFS, AND OTHER
COMMON PRODUCTION PROBLEMS.
designed by PHILLIP TING, SBG ENTERPRISE

F is for FIRST—FIRST DAY COVERS AND
FIRST FLIGHT COVERS ARE HIGHLY SOUGHT
AFTER BY STAMP COLLECTORS.
designed by MELISSA PASSEHL DESIGN

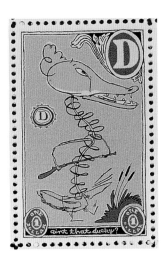
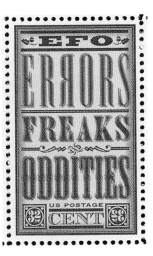
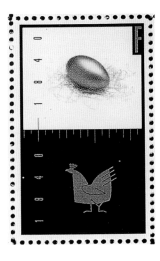

G is for "G" STAMP—BEGUN IN 1994,
THESE NONDENOMINATIONAL STAMPS ARE USED
TO TRANSITION IN A POSTAL RATE INCREASE.
designed by MARTIN VENEZKY,
APPETITE ENGINEERS

H is for HANDSTAMP—REFERS TO
ANY POSTAL MARKING MADE USING A
HAND-HELD STAMP AND INKPAD.
designed by STEVE BARRETTO, FLUX;
JOHN BARRETTO, TOLLESON DESIGN;
TODD FOREMAN, PUBLIC

I is for INVERT ERROR—A STAMP WITH
PART OF ITS IMAGE PRINTED UPSIDE DOWN.
designed by KIT HINRICHS, PENTAGRAM
DESIGN

J is for Joint Issue—similar stamps issued concurrently by two or more countries.
designed by Michael Carabetta, Chronicle Books

K is for Kansas City Roulettes—specially perforated stamps created in 1914 by the postmaster of Kansas City.
designed by Sackett Design Associates

L is for Local Posts—Commemorates the early days of the U. S. mail when it operated only between post offices.
designed by Jean Orlebeke, Orlebeke Design

M is for Mulready Envelopes—decorated, prepaid envelopes that made their debut in England in 1840.
designed by Michael Osborne, Michael Osborne Design

N is for Numerals—indicative of a stamp's value as postage.
designed by Earl Gee, Gee + Chung Design

O is for Overprint—refers to any text, numeral, or design element added to an existing stamp that creates a new one.
designed by Michael Cronan, Cronan Design

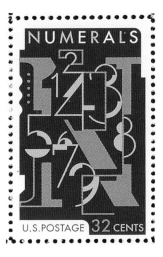

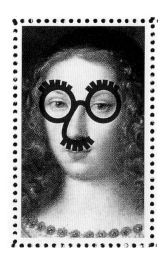

P is for Persian Rug—Issued in 1871, this valuable series of stamps got its nickname because of its larger-than-usual size, and intricate and colorful design.
designed by Elixir Design

Q is for Quality—If you collect stamps, quality is paramount.
designed by Ken Cook, CookSherman

R is for RPO (Railway Post Office)—a special mail car on a train.
designed by Urbain Design

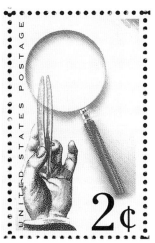

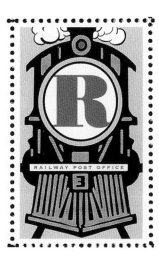

S is for Setenant—two or more stamps, on the same pane, with different design, color or denomination. designed by Diane E. Carr, c/o AIGA/San Francisco

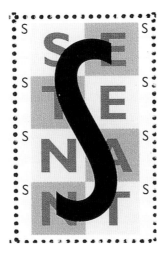

T is for Topicals—stamps relating to a particular theme or topic, such as birds. designed by Kelly Tokerud, big

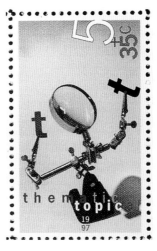

U is for UPO (Universal Postal Union)—a worldwide alliance of postal administrations. designed by Mya Kramer Design Group

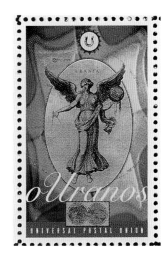

V is for V-Mail—During World War II, letters to and from servicemen were sent using V-mail, a mail photocopying system used by the U.S. designed by Michael Vanderbyl, Vanderbyl Design

W is for War Issues—specialized stamps and applications that arise out of necessity during times of war. designed by Michael Schwab

X is for "X"—a manuscript cancel or the Roman numeral "10." designed by Mark Fox, BlackDog

Y is for Yvert & Tellier—a company that publishes French-language stamp catalogs for world distribution. designed by DelRae Roth, Atelier Graphique

Z is for Zeppelin Post—a term to refer to mail transported by zeppelin. designed by Courtney Reeser, Landor Associates; Jamie Calderon

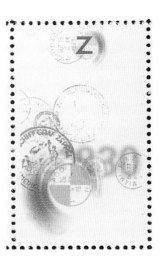

design firm: MICHAEL OSBORNE DESIGN
art director: MICHAEL OSBORNE
designers: MICHAEL OSBORNE,
PAUL KAGIWADA
illustrators: 26 DESIGNERS LISTED
SEPARATELY
copywriters: BILL SENKUS,
SHERYN LABATE, ALYSON KUHN
printer: DICKSON'S, INC.
paper stock/printing:
box wrap: LITHOGRAPHED 3 PMS INKS,
4 HITS OF WHITE, AND BLACK; ENGRAVED
1 PMS INK AND BLACK ON GMUND HAVANNA
NUBES, STRUCTUROS FINISH, 91 LB. TEXT
box interior and trays: HAND-WRAPPED IN
GMUND HAVANNA NUBES, STRUCTUROS
FINISH, 91 LB. TEXT
book cover: LITHOGRAPHED 2 PMS INKS,
BLACK, AND 4 HITS OF WHITE; ENGRAVED
1 PMS INK AND BLACK ON GMUND HAVANNA
CASCARA, STRUCTUROS FINISH, 91 LB. TEXT
introducton pages: PAGE 1—LITHOGRAPHED
2 COLOR, ENGRAVED 1 PMS INK AND
BLACK; PAGES 2, 3, AND 4—LETTERPRESSED
1 COLOR ON GMUND HAVANNA NUBES,
STRUCTUROS FINISH, 91 LB. TEXT
tab pages: LITHOGRAPHED 2/2 AND
DIE-CUT ON GMUND HAVANNA PEARLA,
STRUCTUROS FINISH, 111 LB. COVER

definition pages: LITHOGRAPHED 1 PMS
INK; LETTERPRESSED BLACK AND 1 PMS
INK ON GMUND HAVANNA BLANCO,
STRUCTUROS FINISH, 91 LB. TEXT
black pages: GMUND HAVANNA BLANCO,
STRUCTUROS FINISH, 68 LB. TEXT
appendix pages: PAGES 1 AND 2—LETTER-
PRESSED BLACK; PAGE 3—LITHOGRAPHED 1
PMS INK, ENGRAVED BLACK, AND LETTER-
PRESSED BLACK; PAGE 5—LITHOGRAPHED
BLACK ON GMUND HAVANNA ARENA,
STRUCTUROS FINISH, 91 LB. TEXT

stamps:
A is for Advertising Covers—LITHOGRAPHED
4-COLOR PROCESS; SCULPTED EMBOSS
B is for Bisect—LITHOGRAPHED BLACK,
GREEN, BLUE; ENGRAVED ORANGE
C is for Cinderella Stamp—LITHOGRAPHED
BLUE, GREEN; FOIL STAMPED BLACK;
ENGRAVED GOLD
D is for Duck Stamps—LITHOGRAPHED
4-COLOR PROCESS; LETTERPRESSED RED;
FOIL STAMPED CLEAR
E is for EFOs—LITHOGRAPHED 4-COLOR
PROCESS; FOIL STAMPED TINT PINK,
TINT OCHRE
F is for First—LITHOGRAPHED BLACK,
GOLD, LAVENDER; FOIL STAMPED GOLD

G is for "G" Stamp—LITHOGRAPHED
4-COLOR PROCESS; ENGRAVED WHITE
H is for Handstamp—LITHOGRAPHED 4-
COLOR PROCESS; ENGRAVED RED; FOIL
STAMPED CLEAR
I is for Invert Error—LITHOGRAPHED BLACK,
CREAM; THERMOGRAPHED RED, BLUE
J is for Joint Issue—FOIL STAMPED GOLD;
LITHOGRAPHED 4-COLOR PROCESS
K is for Kansas City Roulettes—
LITHOGRAPHED 4-COLOR PROCESS;
ENGRAVED BLACK
L is for Local Posts—LITHOGRAPHED
4-COLOR PROCESS
M is for Mulready Envelopes—
LITHOGRAPHED 4-COLOR PROCESS;
FOIL STAMPED RED; SCULPTED EMBOSS
N is for Numerals—LITHOGRAPHED BLUE,
FOIL STAMPED METALLIC GREEN, COPPER
O is for Overprint—LITHOGRAPHED 4-COLOR
PROCESS; THERMOGRAPHED INDIGO
P is for Persian Rug—LITHOGRAPHED
4-COLOR PROCESS; ENGRAVED BLACK
Q is for Quality—LITHOGRAPHED BLACK,
RED, GREEN, BROWN; FOIL STAMPED CLEAR
R is for RPO (Railway Post Office)—
LITHOGRAPHED RED, YELLOW; FOIL STAMPED
BLACK, SILVER

S is for Setenant—LITHOGRAPHED YELLOW,
BLUE, GRAY; FOIL STAMPED BLACK;
VARNISHED MATTE, GLOSS
T is for Topicals—LITHOGRAPHED 4-COLOR
PROCESS; FOIL STAMPED PINK, ORANGE
U is for UPU (Universal Postal Union)—
FOIL STAMPED GOLD; LITHOGRAPHED
4-COLOR PROCESS
V is for V-Mail—LITHOGRAPHED BLACK,
GREEN; ENGRAVED BLACK; SCULPTED EMBOSS
W is for War Issues—LITHOGRAPHED
CREAM, GREEN; SINGLE-LEVEL EMBOSS
X is for "X"—LITHOGRAPHED RED, BLUE;
THERMOGRAPHED BLACK
Y is for Yvert & Tellier—LITHOGRAPHED
4-COLOR PROCESS; ENGRAVED YELLOW
Z is for Zeppelin Post—LITHOGRAPHED
4-COLOR PROCESS, PEARLESCENT;
FOIL STAMPED RED
quantity: 3,500
dimensions: ALBUM—
8 1/4" x 8 1/4"
(21 CM X 21 CM)
BOXES—VARIOUS
SHEET OF ALPHABET STAMPS—
8 1/2" x 11" (22 CM X
28 CM); INDIVIDUAL ALPHABET
STAMPS—1 1/4" x 2"
(3 CM X 5 CM)

project: *DICKSON'S EPHEMERA PHILATELICA*, A COLLECTOR'S ALBUM FOR STAMPS
client: **DICKSON'S, INC.**

Michael Osborne Design created Dickson's Ephemera Philatelica for Dicksons, Inc., a high-end, specialty printer in Atlanta, Georgia, to market as a self-promotion through a licensing agreement between Dickson's, Inc. and AIGA/San Francisco. The stamp album comes packaged in a luxurious clamshell box with a snap closure. Inside the front cover, slipped into a glassine envelope, is a full sheet of the twenty-six alphabet stamps as created by designers for AIGA/San Francisco (see pages 172-173). Nested into a tray on the right is a collection of four paper boxes, all with unique die-cut, interlocking closures that invite

exploration. They hold everything a stamp-lover needs to pursue his or her passion: tweezers, photo corners, a magnifying glass, and stamp-sized glassine envelopes.

The one-inch (2.5 cm) thick album is bound with screw posts. It is divided into tabbed sections for each letter of the alphabet, featuring and detailing the significance of the AIGA/San Francisco's philatelic alphabet and including several blank pages for the stamp collector to display his or her own stamps. On each tabbed divider, tucked inside a vinyl pocket, is the stamp for that letter. Dickson's, Inc.

reproduced each of these individual stamps using multiple printing processes for which the firm is renowned. The specialty printing gives the already richly illustrated stamps a tactile finish, depth, and dimension that one wouldn't think possible on a canvas the size of a postage stamp. The artistry of the production values on the stamps rivals the actual box presentation and album construction, which, speaks to the quality of the entire project. This promotion is one to be valued and treasured by recipients for years to come.

6> Contributors

ATELIER GRAPHIQUE
2149 Lyon Street, Suite 4
San Francisco, CA 94115
Telephone: (415) 673-9454
page 173

BASE ART COMPANY
112 Oakland Park Avenue
Columbus, OH 43214
E-mail: base@ee.net
pages 16, 17, 82 , 83

BELYEA
1809 7th Avenue, Suite 1250
Seattle, WA 98101
E-mail: patricia@belyea.com
pages 70, 71, 162

BIG
10 Arkansas, Suite L
San Francisco, CA 94107
Web site: www.2big.net
page 173

BLACKDOG
330 Sir Francis Drake Boulevard,
Suite A
San Anselmo, CA 94960
Web site: www.blackdogma.com
page 173

BÜRO FÜR GESTAUTUNG
Domstrasse 81
D-63067 Offenbach
Germany
E-mail: bfgof@aol.com
pages 90, 91, 159

C3 Incorporated
419 Park Avenue South, 5th Floor
New York, NY 10016
Web site: www.c3inc.com
pages 38, 39

CHEN DESIGN ASSOCIATES
589 Howard Street, 4th Floor
San Francisco, CA 94105
Telephone: (415) 896-5338
E-mail: info@chendesign.com
Web site: www.chendesign.com
pages 94, 95, 140, 141, 166-169

CAROLINE DEVITA DESIGN & ILLUSTRATION
853 21st Street, Suite D
Santa Monica, CA 90403
E-mail: cdevita@loop.com
page 70

CHRONICLE BOOKS
85 Second Street
San Francisco, CA 94105
Web site: www.chroniclebooks.com
page 172

COOKSHERMAN
95 Minna Street, 3rd Floor
San Francisco, CA 94105
Web site: www.cooksherman.com
page 172

CRONAN DESIGN
42 Decatur Street
San Francisco, CA 94103
Web site: www.cronan.com
page 172

DAVID LLOYD BECK
6229 Belmont Avenue
Dallas, TX 75214
E-mail: david@spddallas.com
pages 114-117

DEREK DALTON DESIGN
69 Sturges Street
Staten Island, NY 10304
E-Mail: da1ton@earthlink.net
page 102

DIANE E. CARR
c/o AIGA/San Francisco
1111 Eighth Street
San Francisco, CA 94107
Telephone: (415) 626-6008
page 173

ELIXIR DESIGN
2134 Van Ness Avenue, 2nd Floor
San Francisco, CA 94109
Web site: www.elixirdesign.com
page 172

ERWIN ZINGER GRAPHIC DESIGN
Bunnemaheerd 68
9737 Re Groningen
Netherlands
E-mail: e.zinger@worldonline.nl
page 133

FABRICE PRAEGER
54 Bis, Rue de l'Ermitage
Paris 75020
France
Telephone/Fax: (+33) 1-40-33-17-00
pages 146, 147

FACTOR DESIGN GmbH
Schulterblatt 58
20357 Hamburg
Germany
E-mail: mail@factordesign.com
page 59

5D STUDIO
20651 Seaboard Road
Malibu, CA 90265
E-mail: jane5d@aol.com
pages 22, 111

FLUX
601 Fourth Street, Suite 125
San Francisco, CA 94107
Telephone: (415) 974-5034
page 171

FORMAT DESIGNGRUPPE
Never Kamp 30
20357 Hamburg
Germany
E-mail: ettling@format-hh.com
pages 64-66

FORMGEFÜHL
Lastropsweg 5
20255 Hamburg
Germany
E-mail: marius@formgefuehl.de
page 113

GEE + CHUNG DESIGN
38 Bryant Street
San Francisco, CA 94105
Web site: www.geechungdesign.com
page 172

Gig Design
8640 Sunnyslope Drive
San Gabriel, CA 91775
E-mail: larimie@gigspot.com
pages 68, 99

Grafik Communications
1199 N. Fairfax Street, Suite 700
Alexandria, VA 22209
E-mail: noha@grafik.com
pages 45, 46

Greco Design Studio
Via Reggio Emilia 50
00198 Rome
Italy
E-mail: Greco_design@flashnet.it
page 56

Greenfield/Belser Ltd.
1818 N. Street, N.W., Suite 225
Washington, D.C. 20036
E-mail: mhitchens@gbltd.com
page 34

Greteman Group
1425 E. Douglas
Wichita, KS 67214
E-mail: sgreteman@gretemangroup.com
pages 44, 74

HGV Design Consultants
46A Rosebery Avenue
London EC1R 4RP
United Kingdom
E-mail: design@hgv.co.uk
pages 124-127

Heins Creative, Inc.
2507-B Montana Avenue
Billings, MT 59101
E-mail: heins@mcn.net
pages 36, 37, 60, 61

Hoffmann & Angelic Design
317-1675 Martin Drive
White Rock, BC V4A 6E2
Canada
E-mail: hoffman_angelic@bc.
sympatico.ca
page 93

Hornall Anderson Design Works, Inc.
1008 Western Avenue
Suite 600
Seattle, WA 98104
E-mail: c_arbini@hadw.com
pages 75, 104

Jamie Calderon
Telephone: (415) 701-0050
page 173

Jim Moon Designs
182 Oakdale Avenue
Mill Valley, CA 94941
E-mail: jmoondes@aol.com
pages 55,142-145, 148-151

João Machado Design, Lda
Rua Padre Xavier Coutinho
no 125-4150-751 Porto
Portugal
Web site: www.joaomachado.com
pages 69, 112

Kenzo Izutani Office Corporation
1-24-19 Fukasawa
Setagaya-ku
Tokyo 158-0081
Japan
E-mail: Izutanix@tka.att.ne.jp
pages 28, 29

Level One Design
828 Ralph McGill Boulevard, lb. 315
Atlanta, GA 30306
E-mail: level1@mindspring.com
pages 30, 96, 118

Lewis Moberly
33 Gresse Street
London W1P 2LP
United Kingdom
E-mail: lewismoberly@enterprise.net
page 105

Lieber Brewster Design, Inc.
19 West 34th Street
Suite 618
New York, NY 10001
E-mail: lieber@interport.net
page 119

Likovni Studio D.O.O.
Dekanici 42, Kerestinec
10431 SV. Nedjelja
Croatia
E-mail: tmrcic@list.hr
page 92

Lima Design
215 Hanover Street
Boston, MA 02113
E-mail: beans@limadesign.com
pages 62, 63, 153, 154

Landor Associates
Klamath House
1001 Front Street
San Francisco, CA 94111
Web site: www.landor.com
page 173

Martha Newton Furman
Design & Illustration
2980 Sombrero Circle
San Ramon, CA 94583
Telephone: (925) 866-0462
page 171

METALLI LINDBERG ADV.
VIA GARIBALDI, 5/D
31015 CONEGLIANO TREVISO
ITALY
E-MAIL: LIONELLO.BOREAN@NLINE.IT
PAGES 47, 132

MERYL POLLEN
2525 MICHIGAN AVENUE, G3
SANTA MONICA, CA 90404
E-MAIL: MPOLLEN@EARTHLINK.NET
PAGES 73, 103

MELISSA PASSEHL DESIGN
1275 LINCOLN AVENUE, SUITE 7
SAN JOSE, CA 95125
(408) 294-4422
WEB SITE: MAP@IDEASMPD.COM
PAGE 171

MICHAEL OSBORNE DESIGN
444 DE HARO STREET, SUITE 207
SAN FRANCISCO, CA 94107
WEB SITE: WWW.MODSF.COM
PAGES 174, 175

MIRES DESIGN, INC.
2345 KETTNER BOULEVARD
SAN DIEGO, CA 92101
E-MAIL: DARA@MIRESDESIGN.COM
PAGES 85, 152, 158

MIRIELLO GRAFICO INC.
419 EAST G STREET
SAN DIEGO, CA 92101
E-MAIL: LISA@MIRIELLOGRAFICO.COM
PAGES 100, 101

MYA KRAMER DESIGN GROUP.
604 MISSION STREET, 10TH FLOOR
SAN FRANCISCO, CA 94105
WEB SITE: WWW.MKDG.COM
PAGE 173

NEWMAN FOLEY LTD.
5307 E. MOCKINGBIRD LANE, SUITE 400
DALLAS, TX 75206
PAGES 32, 33

NIKLAUS TROXLER DESIGN
P.O. BOX, CH-6130
WILLISAU
SWITZERLAND
E-MAIL: TROXLER@CENTRALNET.CH
PAGE 87

OH BOY, A DESIGN COMPANY
49 GEARY STREET, SUITE 530
SAN FRANCISCO, CA 94108
E-MAIL: RVIATOR@OHBOYCO.COM
PAGES 19, 84

ORANGE
402-1008 HOMER ST.
VANCOUVER, BC V6B 2X1
CANADA
E-MAIL: PULP@ISTAR.CA
PAGES 120, 160

ORLEBEKE DESIGN
2385 SCOUT ROAD
OAKLAND, CA 94611
TELEPHONE: (510) 334-4677
PAGE 172

PEPE GIMENO—PROYECTO GRÁFICO
CADIRERS, S/N—POL. D'OBRADORS
46110 GODELLA
VALENCIA, SPAIN
E-MAIL: GIMENO@CTV.ES
PAGES 129-131

PENTAGRAM DESIGN
387 TEHAMA STREET
SAN FRANCISCO, CA 94103
WEB SITE: WWW.PENTAGRAM.COM
PAGE 171

PUBLIC
10 ARKANSAS, SUITE L
SAN FRANCISCO, CA 94107
WEB SITE: WWW.PUBLICDESIGN.COM
PAGE 171

R2 DESIGN
PRAÇETA D. NUNO ÁLVARES PEREIRA
20 50 FQ 4450-218
MATOSINHOS, PORTUGAL
E-MAIL: R2DESIGN@MAIL.TELEPAC.PT
PAGES 67, 96

RULLKÖTTER AGD
KLEINES HEENFELD 19
D-32278 KIRCHLENGERN
GERMANY
E-MAIL: INFO@RULLKOETTER.DE
PAGE 98

SBG ENTERPRISE
1725 MONTGOMERY STREET
SAN FRANCISCO, CA 94111
WEB SITE: WWW.SGB.COM
PAGE 171

SACKETT DESIGN ASSOCIATES
2103 SCOTT STREET
SAN FRANCISCO, CA 94115
WEB SITE: WWW.SACKETTDESIGN.COM
PAGE 172

SAGMEISTER INC.
222 WEST 14 STREET
NEW YORK, NY 10011
E-MAIL: SSAGMEISTE@AOL.COM
PAGES 18, 80, 81, 138, 139

SAYLES GRAPHIC DESIGN
3701 BEAVER AVENUE
DES MOINES, IOWA 50310
E-MAIL: SAYLES@SAYLESDESIGN.COM
PAGES 40, 41, 161

SCHUMAKER
466 GREEN STREET
SAN FRANCISCO, CA 94133
WEB SITE: WWW.WARDDRAW.COM
PAGE 171

SHANE LEWIS DESIGN
4445 HIDDEN SHADOW DRIVE
TAMPA, FL 33614
E-MAIL: SLEWIS3@TAMPABAY.RR.COM
PAGES 88, 89

Starbucks Coffee Company/
Starbucks Design Group
2401 Utah Avenue South
Seattle, WA 98134
Telephone: 1-800-Starbuc
pages 48, 49

Studio GT & P
Via Ariosto, 5
06034 Foligo (PG)
Italy
E-mail: gt&p@clint.it
pages 26, 27, 155-157

Studio Karavil
Corso di P. Ticinese 50
20123 Milan
Italy
E-mail: bessikaravil@tin.it
page 31

Terrapin Graphics
991 Avenue Road
Toronto, Ontario M5P 2K9
Canada
E-mail: james@terrapin-graphics.com
pages 20, 21, 86, 110

Tolleson Design
220 Jackson Street, Suite 310
San Francisco, CA 94111
E-mail: jbarretto@tolleson.com
page 171

Urbain Design
55 New Montgomery Street
Suite 708
San Francisco, CA 94105
Telephone: (415) 974-5152
page 172

US Web CKS
410 Townsend Street
San Francisco, CA 94107
Telephone: (415) 284-7070
page 171

Vanderbyl Design
171 Second Street
San Francisco, CA 94105
Web site: www.vanderbyldesign.com
page 173

VIA, Inc.
582 E. Rich Street
Columbus, OH 43215
E-mail: spomponio@vianow.com
page 35

Vrontikis Design Office
2021 Pontius Avenue
Los Angeles, CA 90025
E-mail: pv@35k.com
page 97

Yfactor Inc.
2020 Clark Boulevard, Suite 1B
Brampton, Ontario L6T 5R 4
Canada
E-mail: info@yfactor.com
pages 54, 67

Zingerman's
218 N. Fourth Avenue
Ann Arbor, MI 48104
E-mail: npomaranski@zingermans.com
pages 23, 57

Cheryl Dangel Cullen is a writer and public-relations consultant specializing in the graphic arts industry. She is the author of *Graphic Design Resource: Photography, The Best of Annual Report Design,* and *Direct Response Graphics.* Cullen writes from her home near Ann Arbor, Michigan, and has contributed articles to *How* magazine, *Step-by-Step Graphics, Graphic Arts Monthly, American Printer, Printing Impressions,* and *Package Printing & Converting,* among others. She frequently gives seminars on innovative ways to push the creative edge in design using a variety of substrates. Cullen Communications, a firm she founded in 1993, provides public-relations programs for clients in the graphic arts, printing, paper, and ephemera industries.